# THOMAS GAINSBOROUGH

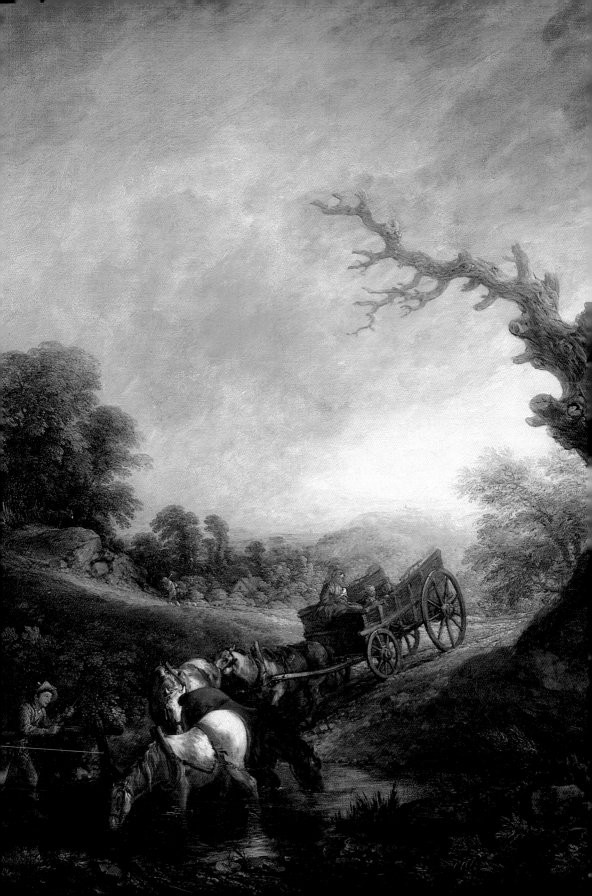

# THOMAS GAINSBOROUGH

Martin Postle

British Artists

Tate Publishing

## To Martine and Rob

*Acknowledgements*

I would like to thank Richard Humphreys for giving me the opportunity to contribute to this series, and my editor at Tate Publishing, Nicola Bion, who made the project such an enjoyable experience. I am also grateful to my picture researchers Celia Dearing and Julia Harris-Voss for their enterprise and hard work. Among those who have given me the benefit of their knowledge and expertise I would particularly like to thank Nicholas Alfrey, Marie Banfield, Rica Jones, Anthony Mould, Susan Sloman, William Vaughan, and the anonymous readers whose judicious comments proved especially valuable.

Over the past century Gainsborough has attracted the attention of a number of scholars, whose research has formed a bedrock for later generations. I am thinking here particularly of William T. Whitley, Sir Ellis Waterhouse, and, in more recent years, John Hayes, whose lifelong devotion to the subject is reflected by his exhaustive list of publications and the knowledge he continues to share generously with fellow researchers. I also owe a personal debt of gratitude to the late Alastair Smart and to Robin Simon, who first taught me to appreciate the art of Gainsborough. Finally, I would like to thank my wife Martine and my son Rob for their constant support. As ever, they gave me the time and space to write, and I dedicate this book to them with love.

First published 2002 by order of
the Tate Trustees
by Tate Publishing, a division of
Tate Enterprises Ltd,
Millbank, London SW1P 4RG
www.tate.org.uk

© Tate 2002

British Library Cataloguing in Publication Data
A catalogue record for this book is available from the British Library

ISBN 1 85437 415 X

Concept design James Shurmer
Book design Caroline Johnston
Printed in Hong Kong by South Sea International Press Ltd

Front cover: *Giovanna Baccelli* 1782
(fig.46, detail)
Back cover: *Open Landscape ... c.*1753–4
(fig.26, detail)
Frontispiece: *Sunset: Carthorses Drinking at a Stream c.*1759–62
(fig.31, detail)
Measurements of artworks are given in centimetres, height before width, followed by inches in brackets

# CONTENTS

# 1

# 'NATURE WAS HIS TEACHER'

In the spring of 1788, a landscape that Thomas Gainsborough had painted some forty years earlier was auctioned in London for seventy-five guineas. This picture, entitled *Cornard Wood*, now belongs to the National Gallery in London (fig.1). A large work, it depicts in painstaking detail the activities of ordinary people working on and travelling through a piece of common land close to Gainsborough's boyhood home in Sudbury, Suffolk. A few days after the sale Gainsborough reminisced about the picture to a friend. 'It is in some respects', he said, 'a little in the schoolboy stile – but I do not reflect on this without a secret gratification; for – as an early instance how strong my inclination stood for Landskip, this picture was actually painted at Sudbury, in the year 1748: it was begun before I left school; – and was the means of my Father's sending me to London.'[1] A few months after writing this letter, Gainsborough died. In his obituary Gainsborough's correspondent, the Reverend Henry Bate-Dudley, stated that 'nature was his teacher and the woods of Suffolk his academy'.[2]

In highlighting the formative role that 'nature' had played in his education, Bate-Dudley was suggesting not just that Gainsborough had been inspired by his native landscape but that he relied upon innate ability rather than the rules imposed by art academies. Sir Joshua Reynolds, President of the Royal Academy, said something similar in a lecture later the same year. Gainsborough's 'grace was not', he said, 'academical or antique, but selected by himself from the great school of nature': he had risen to fame 'without the assistance of an academical education, without travelling to Italy, or any of those preparatory studies which have been so often recommended'.[3] Reynolds, who believed in the efficacy of academic education, and had been Gainsborough's great rival in portraiture, was being critical. Following his death in 1792, Reynolds's academic merits were contrasted with Gainsborough's homespun talent. Reynolds, the artist-statesman, commanded cool respect, while Gainsborough, the Suffolk lad, was greeted with warm affection. This image endeared Gainsborough to the public over many generations. At the same time it hindered attempts to form a more sophisticated critical evaluation of this most cosmopolitan of beings.

Commentators have speculated about Gainsborough's intellectual aspirations. He was anything but bookish, and claimed to be easily bored by the minutiae of philosophical debate and academic enquiry. As his lively correspondence reveals, Gainsborough had a quick mind. He was by turns witty, well informed, devout, and deeply humane. He was also cynical and opinionated. Despite Reynolds's misgivings about his lack of academic education, Gainsborough was a professionally trained artist with an appreciation of the

traditions of Western European art. Even so, in the months and years after his death he was mythologised as a stay-at-home, fundamentally 'English' artist, whose achievement was understood best by the people of his own country. His reputation as a 'natural painter' was tied to an ability to paint but not necessarily to think. Although he was recognised as one of the foremost painters of the British School, he was viewed as a truant who had wilfully trod his own wayward path, indifferent to the traditions of European art that so preoccupied Reynolds and his 'academic' acolytes. Gainsborough, as a prominent Victorian writer noted, 'early discarded all he had learned from the bygone schools, and gave himself up wholly to Nature'.[4] Gainsborough was a 'natural painter', in the sense that his art was informed by a close attention to the visual appearance of objects and the world around him. He was also a master of artifice.

Gainsborough grew up in Sudbury, where his father's family had traded as wool merchants for several generations. The Gainsboroughs were prominent members of the local business community and the Nonconformist Church, factors which were to shape Gainsborough's art and life: his keen business sense, his striving for success, and an abiding awareness of his own human frailties. John Gainsborough, the artist's father, was a clothier. Had he prospered, Gainsborough might well have entered the family business. As it was he failed, compelling Gainsborough to depend upon the meagre charity of an uncle who supplied him with just enough money to enter 'some Light handy Craft trade', with the promise of a little more, 'if he shall prove sober and likely to make good use of it'.[5] A few years ago a modest self-portrait of the young Gainsborough, aged about twelve, holding a paintbrush and palette, came to light in a private collection in Suffolk (fig.2): clearly he was already gaining competence as a painter as well as a draughtsman.[6] Whether he had

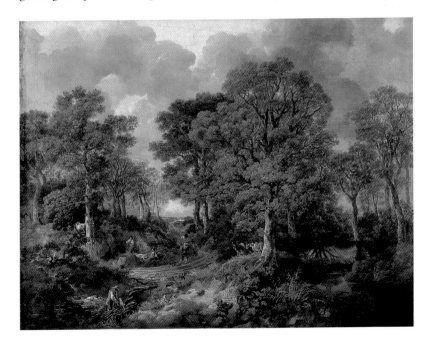

1 *Cornard Wood, near Sudbury, Suffolk* 1748
Oil on canvas
121.9 × 154.9
(48 × 61)
National Gallery,
London

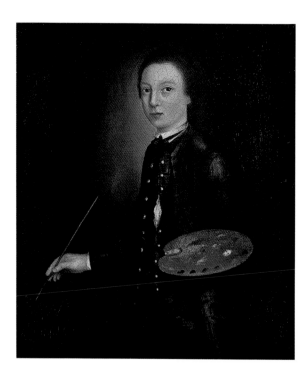

already started to paint *Cornard Wood*, as he later seemed to suggest, is doubt-
ful. He may have made some compositional sketches: ultimately, we cannot
tell. In the letter of 1788 he says that it was begun before he 'left school'. Gains-
borough attended Sudbury Grammar School, then run by his maternal uncle.
Bate-Dudley recalled that he had painted 'several landscapes from the age of
ten to twelve'.[7] Given that Gainsborough left Sudbury for London in 1740, at
the age of thirteen, he was probably already painting when still at school. But
it was in London, and not Suffolk, that Gainsborough's artistic education
began in earnest.

Details of Gainsborough's early career in London are sparse. At first he
lodged with a silversmith, an individual, we are told, 'of some taste', and from
whom 'he was ever ready to confess he derived great assistance'.[8] It was prob-
ably this man who introduced Gainsborough to his master, the influential
French designer and illustrator Hubert-François Bourguignon, better known
as Gravelot. By the early 1740s Gravelot was deeply involved in the adminis-
tration and politics of the St Martin's Lane Academy, a school of art founded
originally in 1720 and relaunched by William Hogarth in 1735. Gainsborough
probably attended St Martin's Lane, where both Gravelot and Hogarth offered
instruction. As a French observer noted a few years later, the teaching was
'admirably adapted to the genius of the English: each man pays alike; each is
his own master; there is no dependance [*sic*]; even the youngest pupils with
reluctance pay a regard to the lessons of the masters of the art, who assist
there continually with an amazing assiduity'.[9]

In Gravelot's studio Gainsborough studied alongside the engraver Charles
Grignion 'and several others, at his house in James Street, Covent Garden,

where he had all the means of study that period could afford him'.[10] There, Gainsborough would have assisted with decorative book illustrations and related design projects. Gravelot may have also instructed him in etching – although he was not apparently skilled in engraving, which was undertaken for him by Grignion.[11] Gravelot, who had worked in London since 1732, was foremost in introducing the taste for French rococo to British artists. Like the rococo itself, Gravelot underwent something of a transformation on British soil. He was, recalled Grignion, 'not at all French in his manner', and worked industriously in his house for months on end in his dressing gown and slippers.[12] In France the rococo was characterised both in terms of its subject matter and style as light-hearted, irreverent, and quite decadent. Rococo in its anglicised form took on a moral dimension, as its decorative forms were employed by Hogarth and his fellow St Martin's Lane artists to promote domestic virtues, through subject matter drawn from literature, fable, and modern life.

Artistic practice in London during the 1740s was highly collaborative, as different artists brought their particular skills to bear on common projects. Among those who collaborated closely with Gravelot was the painter Francis Hayman, who in turn exerted an important influence on the young Gainsborough. In the nineteenth century Hayman's influence upon Gainsborough was dismissed as pernicious. 'From such a man,' concluded his biographer, 'Gainsborough could learn little of painting and less of morality.'[13] Yet,

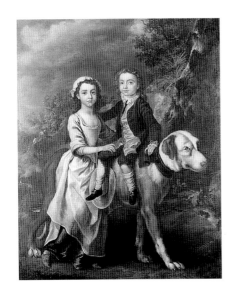

3 Francis Hayman
*Elizabeth and Charles Bedford in a landscape with a St Bernard Dog*
*c.*1746–7
Oil on canvas
76.2 × 63.5
(30 × 25)
Private Collection

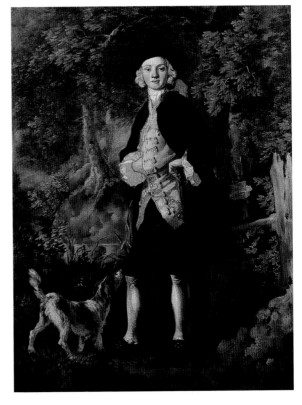

4 *Portrait of a Man with a Dog c.*1746
Oil on canvas
66.5 × 50
(26¼ × 19¾)
Private Collection,
on loan to
Gainsborough's House,
Sudbury, Suffolk

9

Hayman had much to offer Gainsborough besides showing him the city's taverns and whorehouses. Hayman's reputation was then far greater than it is today, not so much as a portraitist but as a painter of literary and historical subjects, and as a mover and shaker in the capital's artistic community.[14] As early as 1743 Gainsborough appears to have contributed a figure to one of Hayman's decorative 'supper box' paintings for Vauxhall Gardens.[15] Several years later he was invited by Hayman to paint the landscape background in his portrait of Elizabeth and Charles Bedford (fig.3).[16] It is not surprising then that Gainsborough's earliest independent portraits (fig.4) are similar to Hayman's, with their stiff, doll-like postures and gangly limbs. But while his portraits retained a stylistic affinity to Hayman for several years to come, Gainsborough also began to evolve his own distinct painting method. In contrast to Hayman, whose pigment is characteristically opaque, Gainsborough began to experiment with translucent paint – exactly when, we do not yet know. As Rica Jones has found by studying pigment samples under high magnification, Gainsborough was mixing ground glass with his pigment by at least the early 1750s. 'Finely-tuned sensibility to the optical properties of paint' was not, says Jones, 'a conspicuous feature of contemporary British painting'; which makes Gainsborough's pioneering technique all the more remarkable.[17]

Francis Hayman's role in Gainsborough's development is relatively clear. More difficult to gauge is the nature of Gainsborough's relationship to William Hogarth, although its importance cannot be denied. By the early 1740s Hogarth was at the peak of his powers. Through his choice of subject matter, drawn from contemporary life, and the dissemination of his images through engravings, Hogarth was reaching out to and creating new audiences for art. He invented a whole new genre through narrative paintings based on contemporary urban life – his so-called 'modern moral subjects'. He also breathed new life and vigour into the existing genres; history painting, large-scale portraiture, and the smaller, more intimate conversation piece. Gainsborough's response to Hogarth's example is evident in his *Conversation in a Park*, of about 1746–7 (fig.5). This painting has often been described as a self-portrait of Gainsborough and his wife – understandable, given that the nineteen-year-old Gainsborough was married in the summer of 1746. Yet this isn't really a portrait at all in the conventional sense – or even a 'conversation piece' – but an amusing vignette dedicated to courtship and rites of sexual passage. The young man is not an artist but a gentleman, as his sword indicates. Inserting his forefinger into the pages of his book he pauses to speak of love, while with his other arm he gestures towards a temple of Hymen set in woodland beyond the lake. The young woman colours slightly, her flickering fan and half-smile subtly indicating that her passion too has been aroused. The 'rococo' elegance of the picture is indebted to Gravelot. The acute observation of manners and sly innuendo are thoroughly Hogarthian.

By the mid-1740s Gainsborough's main interest was landscape painting: 'his first efforts', stated a contemporary, 'were small landscapes, which he frequently sold to the dealers at trifling prices'.[18] Much of what he learnt about landscape at this time derived from seventeenth-century Dutch landscape

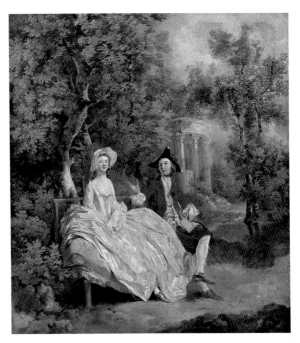

5 *Conversation in a Park* c.1746–7
Oil on canvas
76.2 × 67.3
(30 × 26½)
Musée du Louvre,
Paris

painters, paying close attention not only to the appearance of their works but also their painting technique. He is known to have repaired at least one Dutch landscape and supplied figures for another, something he may have done quite routinely.[19] According to a contemporary source, the Dutch artists who first inspired Gainsborough were Jan Wijnants and Jacob van Ruisdael, whose *Wooded Landscape with a Flooded Road* ('La Forêt') Gainsborough copied in chalks (fig.6). This picture provided the compositional model for a large landscape he painted around 1747 (fig.7). Although this picture is highly derivative, its size – about five feet square – and confident technique demonstrate that by about the age of twenty Gainsborough was an accomplished landscape painter. It is not known who commissioned the painting, although its presence in a Suffolk country house some years later suggests it might have been made specifically to order, possibly as a decorative overmantel.

Gainsborough was perhaps the first native English artist single-mindedly to pursue the Dutch landscape tradition as his chosen model. His initial appreciation of Dutch landscape may have been fostered by the physical resemblance of his native East Anglia to the lowland regions of the Netherlands. It was not, however, in rural Suffolk but in London that collectors first began to take a serious interest in painters of the Dutch Lowlands, such as Ruisdael and Wijnants. This was happening, moreover, in the 1740s, at the very time that Gainsborough was studying them most intensively. The promoters of this new taste included wealthy aristocrats, such as the Duke of Bedford, who also became Gainsborough's patron. Gainsborough's fascination for 'pure' Dutch landscape painting was therefore conditioned by a desire to exploit a type of art which was beginning to be appreciated in the most cosmopolitan circles. Business acumen as well as passion for his subject surely acted as a motivation.

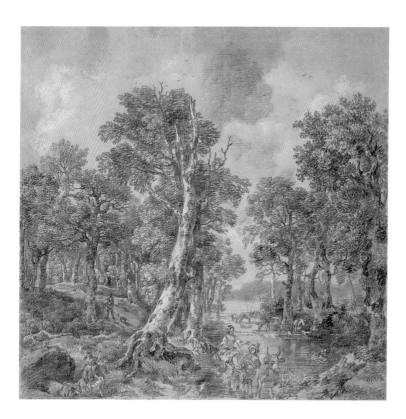

6 *Landscape after Ruisdael's 'La Forêt'*
c.1747
Black and white chalks
on pink paper
40.8 × 42.2
(16 × 16½)
The Whitworth Art
Gallery, The University
of Manchester

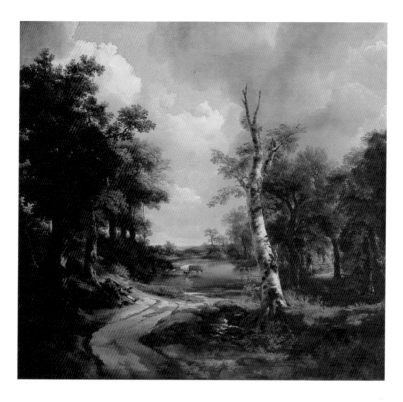

7 *Wooded Landscape with Cattle at a Watering Place (Drinkstone Park)*
c.1747
Oil on canvas
145 × 155
(57½ × 61)
Collection of Museu
de Arte de São Paulo
Assis Chateaubriand

Gainsborough was fortunate in having a wealthy wife – an illegitimate daughter of Henry Somerset, 3rd Duke of Beaufort. Thanks to an annuity from her deceased father, she had an allowance of £200 a year, which Gainsborough relied on for many years to come. Still, he had to show, at least for his own self-respect, that he could make money by his art. Some works he made as speculations, selling them through art dealers' windows. Others were commissioned. One such work was a view of Holywells Park, Ipswich (fig.8). The picture features a series of man-made ponds constructed in the 1740s by the industrialist, Thomas Cobbold, to supply his brewery with pure spring water.[20] *Holywells Park* is unusual in being one of only a handful of landscapes by Gainsborough that can be linked to specific places. Another is *Cornard Wood*, with its view of the village of Great Henny, close to the artist's birthplace. The difference is that while *Cornard Wood* stresses continuity, as the woodsmen and villagers go about their seasonal business, in harmony with the natural landscape, *Holywells Park* is thoroughly unnatural, despite the token presence of the lone peasant in the foreground. It is to Gainsborough's credit that he manages to convince us, through the play of light upon the water and shadows cast by passing clouds, that one man's artificial creation can be comfortably absorbed into a landscape undisturbed for centuries. Thus, Gainsborough enabled Mr Cobbold to enjoy the financial rewards gained by his thoroughly modern intervention, satisfied that he had done so within the bounds of taste and tradition.

8 *Holywells Park, Ipswich c.*1748–50
Oil on canvas
50.8 × 66 (20 × 26)
Ipswich Borough
Council Museums
and Galleries

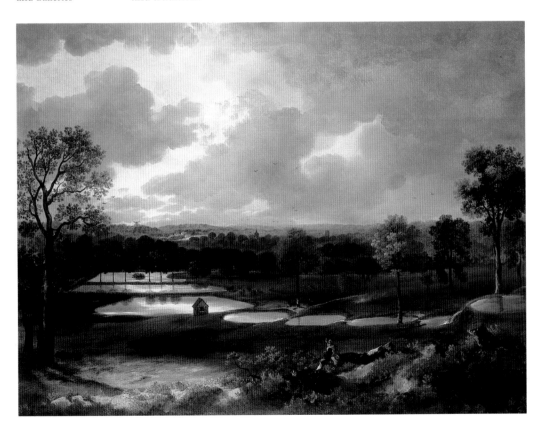

In 1748 Gainsborough contributed a painting to the Foundling Hospital, *View of the Charterhouse* (fig.9). The significance of the commission cannot have been lost on him. The Foundling Hospital had been established in 1739 by Royal Charter as a home for orphaned children by the merchant seaman Thomas Coram, and vigorously promoted since that time by Hogarth as an exhibition venue for contemporary British art. By donating works artists gained a sense of civic pride. At the same time they hoped that the wealthy philanthropists whose money supported the Hospital would bestow patronage upon them also.[21] The Foundling Hospital was a gallery for British artists, and a tremendous commercial opportunity. Participation was by invitation only: Gainsborough, at the age of twenty-one, was the youngest artist by some margin. His picture was one of eight identically sized decorative roundels, which depicted London's various hospitals and charitable institutions. Although modest in size, the picture is remarkable in a number of ways. First, it is painted on a finely woven piece of canvas, prepared with a light orange ground – a technique he had probably learnt from seventeenth-century Dutch landscape practice. As Rica Jones has revealed, this is the earliest-dated picture by a British artist to have a ground of this colour, which imparts a warm tonality to the picture. Indeed, as Jones notes, the other seven roundels made for the Foundling Hospital are all painted on more coarsely woven canvas, cut from the same roll, and are uniformly primed with a conventional light grey ground.[22] Gainsborough's composition, as well as his technique, is also dramatically different. Unlike most of the other pictures in the series, which depict the relevant buildings from a distance, Gainsborough takes us right inside the cloistered world of the school. Uniquely, he has responded to the challenge presented by the round canvas, the circular composition forming a virtual peephole, as the eye is channelled swiftly down the stone-flagged pavement, partially illuminated by a sharp blade of sunlight. The dramatic foreshortening employed here suggests, perhaps, the use of an optical device, a 'Claude glass' (the concave mirror then commonly used by artists to formulate landscape compositions) or possibly even a camera obscura.

Gainsborough's career as a landscape painter during the 1740s can be traced through some thirty paintings, which, although they are undated, provide a series of benchmarks in the evolution of his art. The same cannot be said for his portraiture, where the evidence is scantier. Among his more ambitious portraits dating from this early period is that of two unknown children. Sadly, it exists today only in the form of two dislocated fragments – the figure of a boy (fig.10) and the head of a seated girl.[23] Despite the existence of this,

9 *View of the Charterhouse* 1748
Oil on canvas
55.6 × 55.3
(21⅞ × 21¾)
Coram Foundation,
Foundling Museum,
London

and a handful of larger portraits, Gainsborough evidently preferred to work on a smaller scale. When he first came to London the French-inspired vogue for small-scale group portraits showing subjects in informal circumstances (so-called 'conversation pieces') was still in full swing: both Hogarth and Hayman were seasoned practitioners. Yet by the time Gainsborough reached maturity the novelty had worn off – at least in the capital. This may explain why it was not until after Gainsborough left London in 1749 for Suffolk that he began to regard the genre as a viable means of making a living. It was at this moment that he painted one of the most arresting and original pictures of the eighteenth century, *Mr and Mrs Andrews* (fig.11).

*Mr and Mrs Andrews* was virtually unknown before 1927, when it was first exhibited in Ipswich. Since then it has been regarded as a key work in the artist's career. Despite its reputed 'friendly naturalness of vision', the picture is by no means easy on the eye.[24] Nor is the couple particularly amiable. Mr Andrews exudes a brashness born of youthful affluence, his self-confidence reflected by the manner in which his figure occupies the full height of the canvas, from his buckled shoe to the jaunty angle of his tricorne hat. His wife's expression is deadpan, even sour, lending her an air of remoteness from the viewer and her immediate surroundings. Her lap is empty save for the vestigial

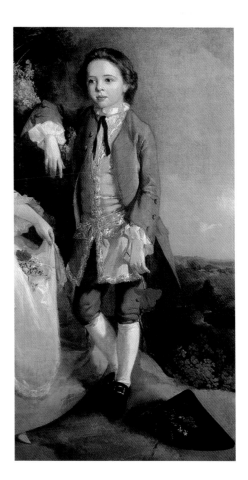

10 *Portrait of a Boy*
mid-1740s
Oil on canvas
133.3 × 72.4
(52½ × 28½)
Gainsborough's
House, Sudbury,
Suffolk

presence of a pheasant, indicated by a feathery streak of brown paint; the omission highlighted by the surrounding patch of bare canvas. As both the artist and his sitters would have been acutely aware, placing a dead game bird in a lady's lap, rather than the customary nosegay, contravened codes of etiquette. That this patch of canvas remained completely blank (in an otherwise highly finished picture) suggests, possibly, that the omission was planned. If so, it may have been a sort of private joke, to which the sitters would presumably have been party.[25]

It is not known exactly when Gainsborough painted *Mr and Mrs Andrews*. Some scholars, who view the picture primarily as a marriage portrait date it to 1748, the year in which the Andrewes were wed. Others prefer 1750, which is perhaps more acceptable on stylistic grounds: 1750 was also the year that Robert Andrews took sole possession of Auberies, the Essex estate where Gainsborough had painted him, together with his young wife, Frances. This is surely significant because the picture is less a celebration of connubial bliss than a statement of ownership: the portrait of a successful business merger as much as a marriage. Mr Andrews was a property owner, his marriage having secured the promise of his wife's half-share in the estate: both she and her land were now his. The relationship between the couple therefore has a significant bearing upon the appearance and organisation of the farmed landscape in the painting: 'the crop of wheat, the venerable oak, fat sheep, wild partridges and everything else are appropriated by the landowner who stands complacently in front of these accumulated assets.'[26] Gainsborough may, as his obituarist stated, have been by 'Heaven and not a master taught': but the rules of artistic engagement were prescribed as much by human ambition as divine ordination.[27]

11 *Mr and Mrs Andrews* c.1750
Oil on canvas
69.8 × 119.4
(27½ × 47)
National Gallery, London

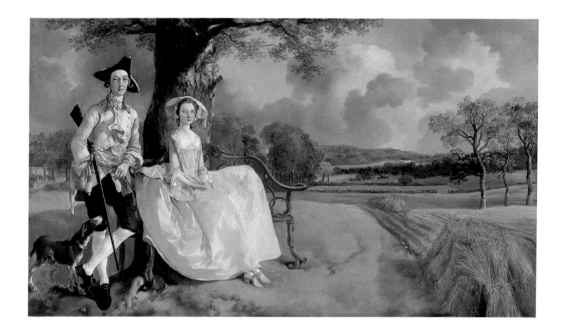

# 2

# 'THE CURS'D FACE BUSINESS'

In July 1770 Gainsborough wrote to a friend complaining about the pressure of society portraiture, which he described as 'the curs'd Face Business'.[1] As he explained, 'the nature of face painting is such, that if I was not <u>already crack'd</u>, the continual hurry of one fool upon the back of another, just when the magot bites, could be enough to drive me Crazy'.[2] The situation could not have been more different from that which had faced him when he moved to Suffolk in 1749. Then Gainsborough had struggled to find commissions. Now he was charging among the highest prices in England. The appearance of his paintings had also changed radically, from small-scale conversation pieces featuring local squirarchy to grand, life-size portraits of the richest and most influential magnates in the country. Gainsborough had achieved this transformation by virtue of his ability, but also by his determination to carve out a niche in this lucrative, if fickle, market.

Gainsborough had returned to live in Sudbury in 1749, following the death of his father the previous autumn. He remained there for three years, before moving to Ipswich with his wife and two young daughters: Mary, born in 1750, and Margaret, in 1751. At this time he readily turned his hand towards painting small-scale conversation pieces, the kind of portraiture that was clearly preferred by his provincial clientele. Among the first of these pictures was a portrait of Joshua Kirby and his wife (fig.12). Kirby, a prominent churchman, played an important role in introducing Gainsborough to new clients, and the two men became lifelong friends. X-rays taken of this picture have revealed that the tree trunk conceals a classical plinth upon which was mounted a statue of a nymph: perhaps his devout sitters had reservations about introducing such a suggestive motif into their otherwise staid portrait. Another, more sprightly, conversation piece which dates from this period is *Peter Darnell Muilman, Charles Crokatt and William Keable in a Landscape* (fig.13). Crokatt and Muilman were the sons of wealthy immigrant merchants based in Essex, and the portrait was probably commissioned by Muilman's father. Keable – seated with a flute – was a professional portrait painter and a talented amateur musician, and may have acted as both music and drawing master to Crokatt and Muilman. A label on the back of the picture states that Keable painted the figures in this portrait and Gainsborough the landscape. Given the collaborative nature of portraiture at the time, and the fact that Keable was thirteen years Gainsborough's senior, there may be a grain of truth here. Recent technical analysis of the picture has revealed areas of overpainting, suggesting, perhaps, that more than one hand may have been at work.[3] Even if they did not collaborate on this picture, Keable and Gainsborough may have

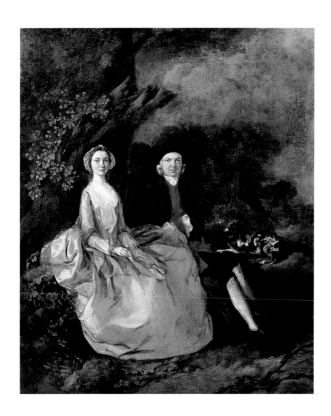

12 *Mr and Mrs
Joshua Kirby* c.1750
74.3 × 61.1
(29½ × 24½)
National Portrait
Gallery, London

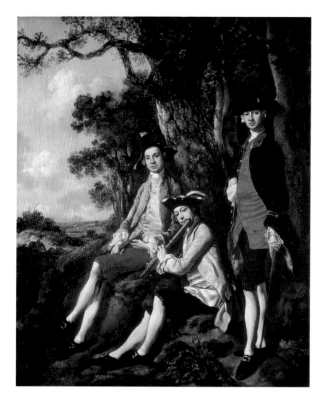

13 *Peter Darnell
Muilman, Charles
Crokatt and William
Keable in a Landscape*
c.1750
Oil on canvas
76.5 × 64.2
(30¼ × 25¼)
Tate and
Gainsborough's
House, Sudbury,
Suffolk

been acquainted, given their mutual interest in music, art and pretty women: for Keable was, like Gainsborough, something of a ladies' man.

Ipswich, where Gainsborough lived from 1752 to 1759, was a bustling coastal town with links to the Continent and nearby Colchester. Gainsborough had plenty of friends there, including fellow members of Ipswich's music club. Now in his mid-twenties he enjoyed a pleasant social life, and was seemingly happy to coast, taking on commissions as they were presented to him. Among those who patronised him was Sir Richard Lloyd of Hintlesham Hall, Recorder of Ipswich, whose two young children, Heneage and Lucy, Gainsborough painted in 1752 or 1753, when they would have been aged between ten and twelve years old (fig.14). The attenuation of the figures – the boy's slender legs dangling lifelessly like those of a marionette – reflects Gainsborough's customary use of a jointed doll, or lay figure, as a model. The boy holds a toy bow, his sister an arrow. While these playthings are common enough in child portraiture of the eighteenth century, it has recently been suggested that Gainsborough has endowed them with a specific emblematic significance, which illustrates the themes of 'innocent attachment' in a real and potentially destructive world.[4] Certainly, such an interpretation is entirely consistent with the sophisticated pictorial strategies used by Hogarth, and with the English visual and literary emblem tradition to which Gainsborough was affiliated.

In 1753 Gainsborough was commissioned to paint a three-quarter-length portrait of the celebrated British naval commander, Admiral Edward Vernon (fig.15), who was then MP for Ipswich. At this point in his career Gainsborough had only limited experience in painting life-size portraits. Still, he needed the commission, not only to raise his profile but to pay the outstanding

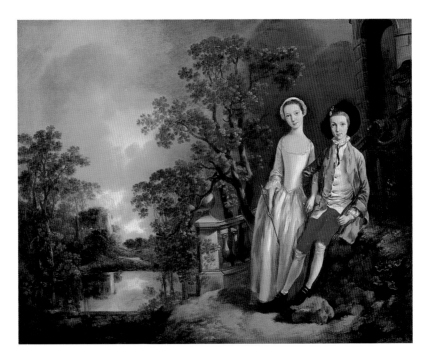

14 *Heneage Lloyd and his Sister c.*1752–3
Oil on canvas
64.1 × 81
(25 × 31½)
Fitzwilliam Museum, Cambridge

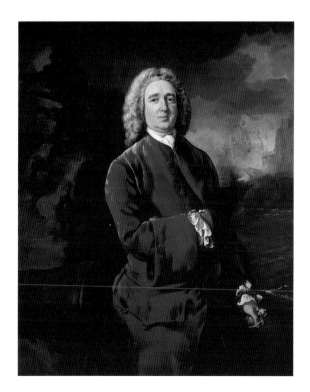

rental arrears on his home.[5] Compared to Reynolds's assured naval portrait of Commodore Augustus Keppel (fig.16), painted around the same time, *Admiral Vernon* appears a little archaic, even timid. But, while the composition descends towards bathos, through the unfortunate positioning of the large cannon at Vernon's rear, it also reveals Gainsborough's strengths: his expert handling of flesh tones and the textures of drapery. It was also, we can assume, a very good likeness; a factor which was to become a hallmark of Gainsborough's eminence as a society portrait painter.

The mid-1750s were difficult years for Gainsborough, as he painted portraits not so much for profit or prestige but to settle debts.[6] In these circumstances he relied heavily upon the support of close friends such as Joshua Kirby. Another friend was Samuel Kilderbee, an attorney and Town Clerk of Ipswich from 1755. Around this time Gainsborough painted Kilderbee's portrait (fig.17), which, like Vernon's, is life-size. The subject, a bluff country squire in hunting attire, was perhaps more to Gainsborough's personal taste than *Vernon*. The attitude of the figure is reminiscent of Hans Holbein's celebrated portrayal of Henry VIII, an image which was by now firmly established as stock-in-trade for the male swagger: Kilderbee grasps his leather girdle, his riding crop forming an effective substitute for the King's dagger. Kilderbee and Kirby were men of influence in the local community. Even so, they could not guarantee Gainsborough an endless stream of sitters: this was, after all, not London but Ipswich. Gainsborough by the mid-1750s was, apparently, painting about seven or eight portraits a year.[7] By comparison, Reynolds, in 1755, entertained well over a hundred sitters in his London

studio. At the same time, Reynolds was already learning that in order to run this 'production-line' business, quality had often to be sacrificed to quantity. Gainsborough, at least, had time on his hands: time to paint, to sketch, and to watch his young daughters grow.

Gainsborough was a loving and indulgent father. He nurtured his daughters' talents, and was fascinated by the emergence of their respective characters. Around 1756 Gainsborough painted them chasing a butterfly (fig.18). The picture has a remarkable air of spontaneity, although this was surely the result of countless hours of observation. Mary clasps the hand of her younger sister, who darts impetuously towards the butterfly. The relative ages of the young girls are indicated by their physique and their behaviour: the elder child holds back to observe and comprehend, while the younger strains to grasp the object of her desire. Through this action the picture assumes an emblematic significance: as the transience of childlike innocence and the harsh lessons of the external world are represented by the frail white butterfly and the prickly thistle. More specifically, it has been suggested, Gainsborough's iconography may have been rooted in a children's rhyme by the poet John Bunyan, entitled 'Of the Boy and Butter-fly'.[8] It appeared in one of the most popular children's books of the period, Bunyan's *Temporal Things Spiritualized*, which Gainsborough would have encountered in his childhood, and may have read to his own daughters. The rhyme may also have inspired Hogarth's painting, *The MacKinnon Children* (National Gallery of Ireland, Dublin), where a boy, who holds a book in his hand, tries to pluck a butterfly from a sunflower.[9] Perhaps Hogarth's picture, too, acted as an inspiration to Gainsborough. If Gainsborough had composed the portrait of his daughters chasing a butterfly with Bunyan's moral tale in mind, the picture's meaning, none the less, is conveyed as much by the manner in which it is painted as the allegorical subject matter. Painted for pleasure, rather than for

Below left
17 *Samuel Kilderbee*
*c*.1755
Oil on canvas
128.3 × 102.9
(50½ × 40¼)
Fine Arts Museums
of San Francisco.
Museum Purchase,
M.H. de Young
Endowment Fund
54479

Below right
18 *The Painter's
Daughters chasing a
Butterfly c.*1756–7
Oil on canvas
113.5 × 105
(44¼ × 41¼)
National Gallery,
London

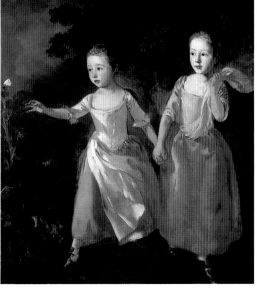

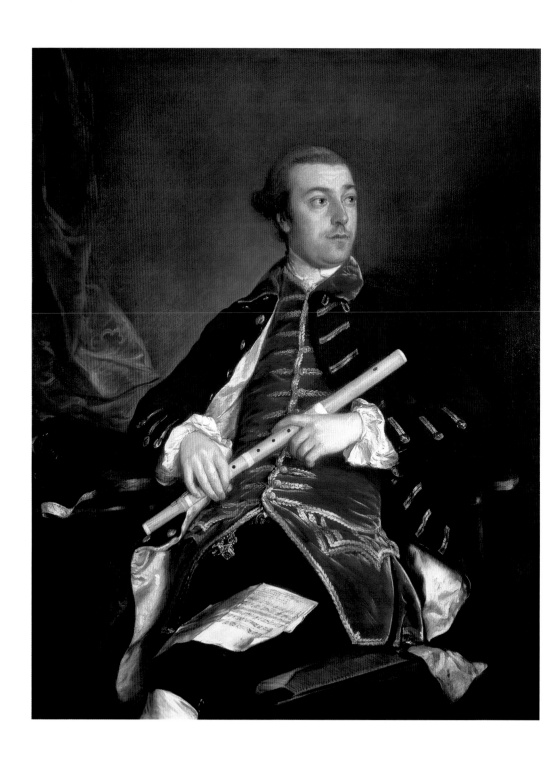

19 *William Wollaston* 1758–9
Oil on canvas 120.7 × 97.8 (47½ × 38½)
Ipswich Borough Council Museums and Galleries

money, this picture demonstrates the importance that he attached to his own technical virtuosity. Great painting, like great music, was, he avowed, to be revealed not so much by ideas as by performance. As he explained to a young aspiring actor some years later, 'what makes the difference between man and man, is real performance, and not genius or conception'.[10]

Gainsborough's faith in the primacy of artistic virtuosity was something that Reynolds found difficult to subscribe to, with his entourage of pupils, assistants and drapery painters. For him, art existed first and foremost to communicate ideas. In this context the relevance of music to Gainsborough's art takes on renewed significance. Gainsborough cherished music and musicians: he was himself a gifted musician, excelling on the viol da gamba. Just as Reynolds was stimulated by conversation in his studio, Gainsborough was inspired by music. Whether its rhythms and harmonies might actually have found some precise equivalent in his own brushstrokes and pictorial patterns is, however, hard to tell. In the eighteenth century intellectual and cultural attitudes towards music underwent a profound transformation. Indeed, as it has been observed, many thinkers worried about the power of music to exercise a 'mysterious, nonverbal command over the passions'.[11] As a result instrumental music, which Gainsborough preferred, was regarded as inferior to that which had a text or narrative. This kind of intellectual snobbery was something that Gainsborough was to face in his own profession in the years to come, although, as his commercial success revealed, he was far from alone in preferring the power of performance to high-flown rhetoric.

Gainsborough's belief that portraiture, which he cynically professed to be merely a means of making money, could be redeemed by the virtuosity of the artist emerges forcibly in the later 1750s. By this time Gainsborough was busy 'in the Face way' and he was, as he admitted, 'afraid to put people off when they are in the mind to sit'.[12] He was bored by routine commissions, such as head-and-shoulders portraits of local merchants and lawyers, and he often tired of them long before they were completed. Yet, when he found a stimulating subject the transformation upon his art was compelling. William Wollaston (fig.19) was a wealthy landowner, a prominent member of the local community, and an amateur musician. His family, who had a keen interest in the arts and sciences, had formed the subject of one of Hogarth's earliest and most celebrated conversation pieces, of 1730 (private collection). Gainsborough's portrait of Wollaston, which owes much to Hogarth's example, speaks volumes about the relaxed bond of intimacy between the artist and his sitter. Wollaston eases back in his chair, revealing the expanse of his richly embroidered waistcoat. The forefinger of his left hand rests lightly upon his instrument, as he turns his head, with only the slightest raise of a quizzical eyebrow – confident, no doubt, in the quality of his own performance.

A brief foray to Bath in the autumn of 1758 persuaded Gainsborough that he could make a good living there from portraiture, and in 1759 he took up residence.[13] The timing was perfect. Bath was then undergoing an economic boom, attracting a host of speculators and entrepreneurs. Gainsborough, too, prospered, augmenting his artistic income by investing in the lucrative boarding-house business.[14] He was anxious, however, not to be cast in the role

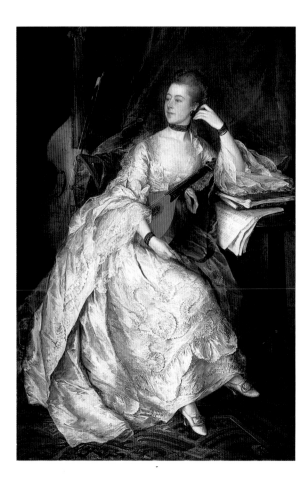

20 *Miss Ann Ford*
1760
Oil on canvas
196.9 × 134.6
(77½ × 53)
Cincinnati Art
Museum, Bequest of
Mary M. Emery
Acc. 1927.396

of a mere businessman. Gainsborough's biographer, George Fulcher, recalled an incident some years later in which a gentleman had burst into Gainsborough's house, enquiring in a loud voice, 'Has that fellow Gainsborough finished my portrait?' As he was ushered into the artist's painting room, Gainsborough told his client that it just needed the finishing stroke. Picking up a loaded brush, he dashed it across the face of the man's portrait, with the words, 'Sir, where is my fellow now?'[15] Given Gainsborough's volatile nature, the story may be true. Gainsborough could curse about gentlemen: 'now damn Gentlemen, there is not such a set of Enemies, to a real Artist, in the World as they are if not kept at a proper distance.'[16] He affected to despise them, but Gainsborough's air of gentility and the elegant manner in which he aspired to live were increasingly those of the gentleman – as was his habitual whoring, swearing, and drunkenness.

According to Philip Thicknesse, the artist's one-time friend and patron, it had been his idea that Gainsborough should transfer his practice to Bath. It is not surprising, therefore, that among Gainsborough's very first sitters was the beautiful and talented Ann Ford, whom Thicknesse was shortly to marry (fig.20). A female visitor to Gainsborough's studio saw the picture in October 1760. It was, she said, 'a most extraordinary figure, handsome and bold; but I

should be very sorry to have any one I loved set forth in such a manner'.[17] Her principal objection was presumably to Miss Ford's cross-legged pose, an attitude associated with male deportment. Gainsborough's portrait was not daring for its own sake, but was a pointed visual response to Ford's own predicament. Despite the opposition even of her own father (who had her arrested on two occasions) Ford persisted in her ambition to perform in public on the viol da gamba. Female public performance was then considered taboo. To make matters worse she wished to play an instrument regarded as the preserve of the male sex.[18] Gainsborough, himself a talented performer on this instrument, must have appreciated Ford's spirit of defiance, so wittily portrayed in this sophisticated portrait of contemporary manners and mores.

Bath introduced Gainsborough to a world of wealth and privilege which he had not known before. In Bath his patrons still included the professional classes: doctors, bankers, lawyers and clerics. Now he attracted prominent members of the landed gentry and aristocracy in increasing numbers. And, just as influential figures flocked to his studio, so he made regular peregrinations to nearby country seats. These included Longford Castle and Wilton House, the respective seats of the Earls of Radnor and Pembroke, and Corsham Court, the home of the MP for Warwick, Paul Methuen. All three houses contained important Old Master paintings. At Longford Castle Gainsborough copied David Teniers the Younger, at Corsham Sir Anthony Van Dyck's portrait of the Duke of Richmond and Lennox, while at Wilton his fascination with the same artist's magisterial group portrait of the Pembroke family prompted him to

21 After Van Dyck
*Sir Thomas Hanmer*
? later 1770s
Oil on canvas
103.5 × 83
(40¾ × 32⅝)
Private Collection

make a small copy from memory. Of those artists whose works he copied, Van Dyck, the seventeenth-century Flemish painter whose elegant portraits immortalized the Court of Charles I, was his undoubted favourite: this is demonstrated by the exceptional quality of his copies (fig.21), which, as Reynolds admitted, could at first sight be mistaken for the originals.[19] Gainsborough emulated the visual effect of Van Dyck's paintings. He also developed an admiration for Van Dyck's artistic persona. As Helen Glanville has observed, Gainsborough cultivated the courtly concept of *sprezzatura* – 'that show of unforced ease of accomplishment and of effortless superiority' which had since the Renaissance been the distinguishing mark of the gentleman.[20] As Gainsborough grew in confidence as a painter he was equally intent on establishing his social credentials in the most cosmopolitan circles.

We know a good deal about Gainsborough's method of painting portraits at this time thanks to the first-hand testimony of the young miniature painter, Ozias Humphry, who then also lived in Bath. Humphry stated: 'He never failed to paint with the canvases loose, secured by small Cords, and brought to extremity to the Frames, and having previously determined and marked with chalk upon what part of the canvases the faces were to be painted, they were so placed upon the Eisel [*sic*] as to be close to the subject he was painting.' The composition was sketched out in semi-darkness, both artist and sitter 'scarcely discernible' to an onlooker.[21] The subdued lighting in Gainsborough's painting room must have been an essential factor in obtaining a good likeness. Another contemporary, who also noted the 'twilight' conditions in Gainsborough's painting room, observed:

> his likenesses are attained by the indecision more than the precision of
> the outlines. He gives the feature and the shadow, so that it is
> sometimes not easy to say which is which, for the scumbling about the
> feature sometimes looks like the feature itself, so that he shows the
> face in more points of view than one, and by that means it strikes
> every one who has seen the original with being a resemblance; that
> while the portrait with a rigid outline exhibits the countenance only in
> one disposition of mind, his gives it in many.[22]

An ability to capture a likeness was integral to the performative aspect of Gainsborough's art. Reynolds, by way of contrast, expressed the belief that likeness detracted from the elevated air with which he wished to endow his portraits. It was, he admitted, 'very difficult to ennoble the character but at the expense of the likeness, which is what is most generally required by such as sit to the painter'.[23] It was, yet, to these people that Gainsborough owed his primary allegiance.

Immediately upon his arrival in Bath Gainsborough leased expensive premises close to Bath Abbey, at the heart of the city's tourist trade, and which he shared with his sister's millinery business. He adapted his painting room to suit his own specialised needs, including a tripartite window with an elongated central light to allow him greater control over lighting conditions. This feature he also incorporated into his house in the Circus, where he lived and worked from the end of 1766 until his departure for London.[24]

22 *George Byam with his wife Louisa and their daughter Selina* c.1762 and before 1766
Oil on canvas
24.9 × 238.8
(98 × 94)
The Andrew Brownsword Arts Foundation, on loan to the Holburne Museum of Art, Bath

Gainsborough's Bath painting room evidently allowed him to produce bigger portraits than ever before. Among the most ambitious of these was *The Byam Family* (fig.22). It was commissioned around 1762, probably to celebrate the marriage of the wealthy plantation owner, George Byam, to Louisa Bathurst in 1760. Several years later it was returned by the owners to Gainsborough, who added a third figure, the Byams' young daughter, Selina: this explains why the adult couple appears to be oblivious to her presence. At this time, Mrs Byam's hairstyle was altered and her dress, originally a pinky red, was changed to blue; her husband's blue waistcoat was repainted in red.[25] Fashion, as well as a desire to register the existence of their offspring, was the guiding principle for the Byams. For Gainsborough, too, fashion in portraiture was important, although his reasons went further than personal vanity. 'I am very well aware of the Objection to modern Dresses in Pictures,' he stated, 'that

they are soon out of fashion & look awkward: but that misfortune cannot be help'd we must set against it the unluckiness of fancied Dresses taking away likenesses, the principal beauty & intention of a Portrait.'[26]

In 1758, the Poet Laureate, William Whitehead, had commented on how Gainsborough's gift for taking a likeness was allied to a technique that was 'coarse and slight'.[27] Since the later 1750s Gainsborough had been developing this schematic surface, composed of short hatched brushstrokes, a technique which approximates more closely to that found in pastels than oil paint. Gainsborough may have first observed this technique in the oil paintings of the Scottish artist Allan Ramsay, who had himself been influenced by contemporary French artists, notably Maurice-Quentin de La Tour. Ramsay had returned from France to London in 1757, and it was here that Gainsborough would have been able to inspect his work. Certainly, Gainsborough maintained strong links with the artistic community in the capital. As his portrait of the celebrated Shakespearean actor James Quin (fig.23) reveals, there is nothing remotely 'provincial' about Gainsborough's portraiture by the early 1760s.

Quin's pose is adapted from an etched portrait by Hogarth of the mid-1740s.[28] It lends the subject a down-to-earth quality reminiscent of the same artist's great full-length portrayal of Captain Thomas Coram. From Hogarth Gainsborough had learnt to trust his own powers of observation, rather than received convention, in order to evoke a 'living presence'. Yet, as Amal Asfour and Paul Williamson have recently suggested, this was achieved by evolving a pictorial language that forms an association in the viewer's mind as well as the eye.[29] It was an approach that derived from a specifically English empirical tradition, where the accumulation of experience and knowledge of the world was acknowledged to rely upon information gathered via the senses. Reynolds, for one, understood that Gainsborough's art relied upon careful observation of nature, 'that he saw her with the eye of a painter'.[30] However, because he believed that this was the result of little more than mere accident or intuition, he was forced to conclude that Gainsborough lacked sufficient intellectual or philosophical depth, or what he described as 'a poet's eye'. Reynolds did not articulate this view publicly until after Gainsborough's death. The differences between the two artists were, however, already apparent in the portraits they showed at London's annual exhibitions organised from 1760 by the Society of Artists. Gainsborough's exhibits included the aforementioned portrait of Quin, shown in 1763, and a full-length of William Poyntz (fig.24), which he had displayed the previous year. In his portrait of Poyntz, here shown in the guise of a virile young sportsman, Gainsborough appears to be indulging in a witty visual innuendo, since the exaggerated upward thrust of the weapon appears to suggest that the subject's prowess is not confined to field sports alone.[31]

The portraits Gainsborough exhibited during the 1760s at the Society of Artists demonstrate that he was constructing a wholly independent strategy. By this time Reynolds had evolved a pictorial method which incorporated visual quotations from Old Master paintings and classical sculpture: men posed in the attitude of Hercules or Apollo and classically dressed women

23 *James Quin* 1763
Oil on canvas
233.7 × 152.4
(92 × 60)
National Gallery of Ireland

disguised as muses and goddesses. But even though Gainsborough was not averse to borrowing from antiquity or the Old Masters, he maintained a fundamental distrust of high-flown allegory. His Hogarthian portrait of James Quin, unlike Reynolds's contemporaneous portrayal of the actor David Garrick, posed between the figures of Tragedy and Comedy (private collection), 'was firmly of the here and now'.[32] The same criterion applies to Gainsborough's formal portraiture. In 1767 he exhibited *John, 4th Duke of Argyll* at the Society of Artists (fig.25). While the artist's superlative technique has been praised, he has been criticised for his 'failure to achieve a suitable grandeur in the pose' – especially when compared to Reynolds.[33] Viewed on its own terms it is entirely successful. Gainsborough convincingly conveys the underlying frailty of the ageing Duke, who, despite the trappings of dynastic power and status, appears to clutch at his coronet for physical and moral support. His legs are bowed slightly; his expression is one of defiance tinged with anxiety.

Below left
24 *William Poyntz*
1762
Oil on canvas
234.9 × 152.4
(92½ × 60)
Althorp

Below right
25 *John, 4th Duke of Argyll* 1767
Oil on canvas
231.1 × 153.7
(91 × 60½)
Scottish National Portrait Gallery

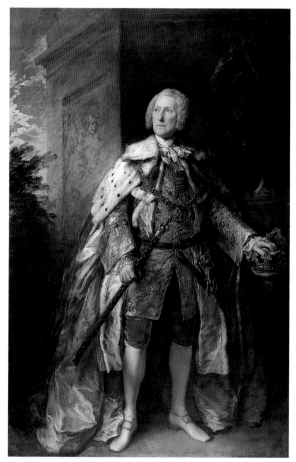

# 3

# 'COMPOSITION IN THE LANDSKIP WAY'

Sometime during the early 1750s a gentleman in Ipswich commissioned Gainsborough to paint a landscape with a group of gypsies: 'When about two-thirds of it were finished – for Gainsborough in his early works, owing to his great execution, finished as he went on – he came to see it, and was not pleased with it; he said he did not like it. Then, said Gainsborough, "You shall not have it;" and taking up his penknife he drew directly across it.'[1] Fortunately, Gainsborough's friend Joshua Kirby rescued the picture and had it mended (fig.26). Gainsborough could be temperamental: but there is something else going on here. Unlike his portraits, which he was prepared to alter at the request of patrons, Gainsborough did not take kindly to criticism of his landscapes. Nor were they usually to be had through mere financial transaction. Instead, he preferred to present them to his associates as tokens of friendship. He did so in the confidence that these pictures represented the purest emanation of his artistic sensibility. While his public profile and financial stability were inextricably bound up with portraiture, landscape represented a more private sphere. Yet, it was landscape rather than portraiture that formed the basis of his posthumous reputation.

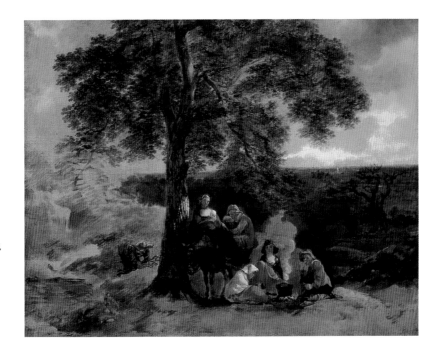

26  *Open Landscape with Wood-gatherer, Peasant Woman with her Baby on a Donkey, and Peasants seated round a Cooking Pot on a Fire c.*1753–4
Oil on canvas
48.3 × 62.2
(19 × 24)
Tate

Few of Gainsborough's landscapes were sold on the open market during his lifetime: *Cornard Wood* (see fig.1) was a notable exception. After his death Gainsborough's landscapes gradually reached a wider audience. In 1814 they featured prominently in the first retrospective exhibition of his art, mounted by the British Institution, where a total of forty-five landscapes were shown, as opposed to only fourteen portraits; which no doubt influenced the *New Monthly Magazine* in its conclusion that Gainsborough's reputation rested 'on the most incontrovertible of all bases, his landscapes'.[2] Gradually, the landscapes made their way into public collections. Among the first was *The Watering Place* (see fig.47), presented to the National Gallery in 1827: this was followed shortly afterwards by *The Market Cart*. The first Gainsborough portraits were not acquired until some thirty years later.[3] In the nineteenth century Gainsborough's landscapes were admired not just for their intrinsic aesthetic appeal but for their apparent espousal of national values: 'the truly English and intrepid spirit of Gainsborough' was epitomised in landscapes indelibly 'stamped with the image of old England'.[4] His supposed insularity became a virtue: 'the fact that he was never warped by foreign study', it was argued, 'left him free to adopt a style and manner entirely his own.'[5] Modern scholarship has since revealed the extent to which Gainsborough's landscapes were inspired by the example of the Old Masters: Ruisdael, Wijnants, Rubens, and Claude Lorrain. Recently, Gainsborough's landscapes of 'old England' have also been studied within the context of Georgian culture and the immense social and political upheavals which affected the age in which they were produced.

Although quite a number of Gainsborough's early landscapes have been identified, comparatively little is known about who owned them and how they were displayed. Exceptional in this sense are two landscapes commissioned in 1755 by John Russell, 4th Duke of Bedford, through the intercession of Joshua Kirby: *Landscape with a Woodcutter and Milkmaid* (fig.27) and *Landscape with Haymakers* (fig.28). The former picture, for which Gainsborough was paid 21 guineas, was described in the Duke's account book as a 'Chimney piece', intended to hang above a fireplace. The second, slightly smaller, work would have occupied a similar position: both pictures probably featured in the redecoration of the Duke's seat at Woburn Abbey, Bedfordshire.[6] Their function as decorative items may, perhaps, account for Gainsborough's marked use of strong colour and sinuous 'rococo' line, which he had absorbed under the tutelage of Gravelot in St Martin's Lane. At the same time these pictures have a strong narrative element. In the first picture a young woodcutter pays court to a seated milkmaid, his eyes straying from the milk pail to her shapely figure: behind, separated by a fence, a ploughman drives his team of horses across a field, while an elderly couple stride purposefully over the brow of the hill to a nearby town. The second picture also presents an image of contrasted work and leisure, as the peasant boy lazes on his mount beneath the shade of a tree, while distant haymakers dutifully go about their labours in the vicinity of a nearby church.

Gainsborough's early landscapes draw upon two complementary literary and visual forms: the pastoral and the georgic. The pastoral tradition paints a

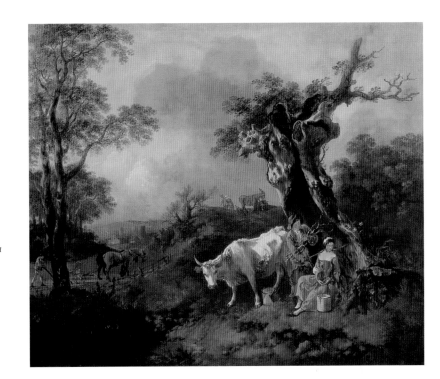

27 *Landscape with a Woodcutter and Milkmaid* 1755
Oil on canvas
106.7 × 128.2
(42 × 50½)
The Marquess of
Tavistock and the
Trustees of the
Bedford Estates

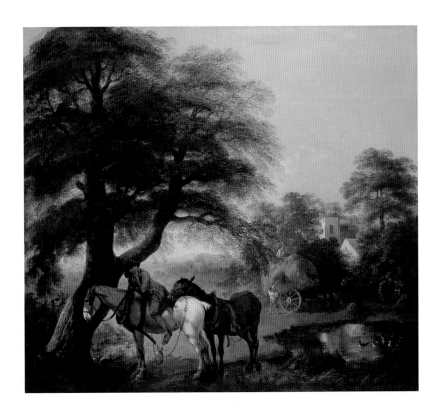

28 *Landscape with Haymakers* 1755
Oil on canvas
92.1 × 102.2
(36¼ × 40¼)
The Marquess of
Tavistock and the
Trustees of the
Bedford Estates

picture of the countryside as an arcadian realm, where rural folk live in blissful harmony with nature and one another; the georgic, on the other hand, celebrates the virtues of husbandry in an agricultural landscape, where the peasant's labour is rewarded by a bountiful harvest. Since antiquity, pastoral and georgic traditions had been explored by poets and painters. In eighteenth-century England the pastoral tradition was omnipresent in music and the visual arts, epitomised by Handel's *Acis and Galatea* and the classical landscapes of Richard Wilson. The georgic tradition emerged forcefully, too, in the works of poets such as John Gay and James Thomson, where the industrious ploughman rather than the idle shepherd assumed centre stage. The promotion of the georgic, it has been argued, was shaped by profound changes in the rural economy and the relationship of the peasant to the land.[7] Among those in the vanguard of agricultural innovation was the Duke of Bedford, one of the country's greatest landowners and 'improvers'. Since Gainsborough's landscapes were designed for display in the Duke's own domicile, perhaps it was his vision, as much as Gainsborough's, that informed the optimistic blend of toil and leisure in these pictures. Certainly, Gainsborough's pictures would have provided his patron with reassurance as well as delight, as the pleasures of rest and play are balanced by the necessary virtues of dutiful labour.[8]

While the Duke of Bedford's purchase of two landscapes in 1755 represented Gainsborough's most prestigious landscape commission to date, it does not appear to have led to purchases by other leading grandees. Among early owners of his landscapes were his old mentor, Francis Hayman, and Hayman's patron, Charles Jennens, who purchased works by many of the artists in the St Martin's Lane circle. Another early owner was Jervoise Clarke,

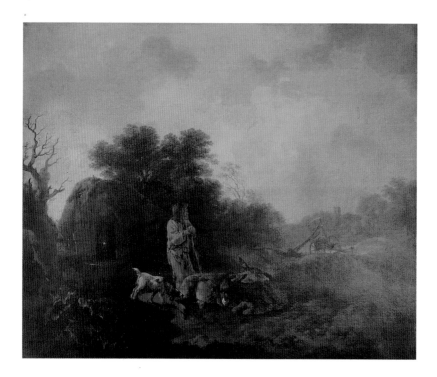

29 *Peasant and Donkeys outside a Barn c.*1755–7
Oil on canvas
49.5 × 59.7
(19½ × 23½)
Private Collection, on loan to Hampshire County Council

30 *Uvedale Tomkyns Price* c.1760
Oil on canvas
124.5 × 99.1
(49 × 39)
Neue Pinakothek,
Munich Bayerische
Staatsgemälde-
sammlungen

who purchased Gainsborough's *Peasant and Donkeys outside a Barn* (fig.29). It depicts an old man leaning on a staff by a hovel. It is evening. As he contemplates the landscape, the man's gaze is directed towards a distant church tower. By the entrance to his humble plot, adjacent to the church, his plough stands idle. The labourer has earned his rest. It is not merely the end of a day, but the closing chapter on a life of labour; and the rest that the old man contemplates is eternal. The picture is a striking example of the way in which Gainsborough's landscapes can, at times, assume a moral dimension.

Gainsborough's relationship with the countryside is often assumed to have been especially intimate, an assumption which has served to perpetuate the myth of Gainsborough as the 'natural' painter. In fact, he was a 'townie', who, while he loved the countryside, was not in any way affiliated to its economic or social structure. He travelled through the countryside, observed it, and sketched it, but invariably as an outsider who was consciously indulging in an aesthetic experience. A companion who accompanied him on rural rides around Bath recalled: 'when we came to village scenes, to groups of children, or to any object of that kind which struck his fancy, I have often remarked in his countenance an expression of particular gentleness and complacency.'[9] This account was written by Uvedale Price, then a precocious teenager. Price went on to make his own reputation as one of the succeeding generation's most prominent writers on the Picturesque. In this respect Gainsborough must have acted as a formative influence.

Gainsborough had become acquainted with the Price family of Foxley, Herefordshire, shortly after his arrival in Bath, when he had painted the

portrait of Uvedale Tomkyns Price (fig.30). He was the grandfather of young Uvedale, and was himself a talented amateur landscape draughtsman. Here he is posed with his drawing materials and portfolio before a framed Gainsborough drawing – an indication of the admiration accorded to the artist's work in this medium. The Prices, in turn, must also have contributed to the development of Gainsborough's own landscape aesthetic. Their friendship and common interests suggest that developments in Gainsborough's landscape art during his Bath years did not occur in isolation. As well as the Price family, Gainsborough's friends included the Reverend Richard Graves who, as early as 1762, published verses 'On Gainsborough's Landskips with Portraits'. This clique consciously pursued the ideal of the countryside as a retreat from the city and society, a so-called 'landscape of retirement'.[10] Gainsborough, too, liked to regard himself as distanced from the hurly-burly of modern urban life – while continuing to indulge in the hedonistic pleasures that the city offered. When he was exhausted by the pressure of portraiture and the dizzy social round, he fondly dreamt of retiring to 'some sweet Village' where he could 'paint Landskips and enjoy the fag End of Life in quietness & ease'.[11] Ambition, however, stood in the way.

The move to Bath, as we have seen, had a considerable impact on Gainsborough's portraits. Its effect upon his landscapes was no less dramatic. For one thing, he found less time to paint them. While in the 1750s he produced over forty recorded landscapes, the following decade he painted half that

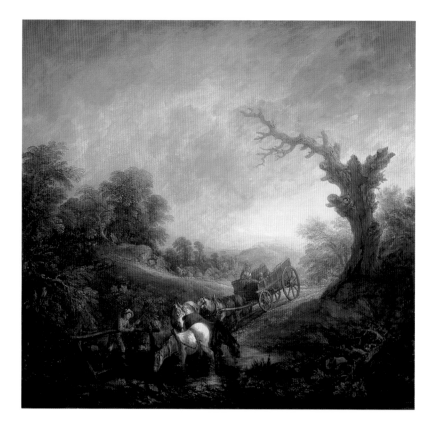

31 *Sunset:*
*Carthorses Drinking*
*at a Stream*
*c.*1759–62
Oil on canvas
142.2 × 151.8
(56 × 59¾)
Tate

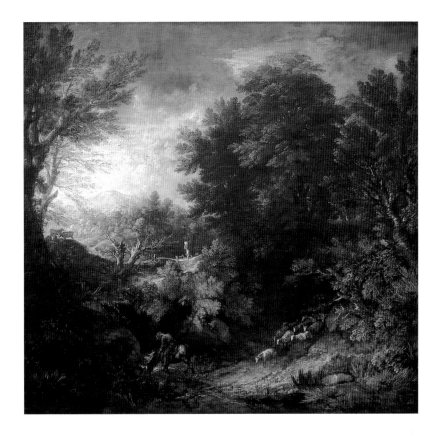

32 *Mountainous Wooded Landscape with Horse Drinking and a Flock of Sheep*
1763
Oil on canvas
146.1 × 157.5
(57½ × 62)
Worcester Art Museum, Worcester, Massachusetts
Museum purchase

number: this was part of the price he paid for commercial success as a por-traitist. Among the first landscapes he painted in Bath was *Carthorses Drinking at a Stream* (fig.31). The contours of the countryside in this picture appear to echo the rolling hills around the city of Bath, suggesting that Gainsborough wished to adapt his landscape art to his new surroundings. At the same time the composition is clearly shaped by the artifice of the painter, typified by the sweeping curve of the blasted tree trunk and the retreating diagonals formed by the intersecting tracks. The lighting is dramatically focused upon the golden sky and the rump of the leading horse. This is among the first of Gainsborough's pictures where the waggon appears as a central motif, here carrying a mother and child upon a homeward journey. Its frequent appear-ance in Gainsborough's subsequent landscapes has provoked the suggestion that it had a symbolic significance, as a vehicle (quite literally) for the human passage through life. It was an image he used to describe his own predicament: while he was compelled by the pressure of work 'to follow the track ... others ride in the Waggon, under cover, stretching their Legs in the straw at Ease, and gazing at Green Trees & Blue Skies without half my <u>Taste</u>'.[12]

During the 1760s Gainsborough continued to share his landscapes prin-cipally with close friends, including his physician, Dr Charlton, and Walter Wiltshire, who transported his pictures to London. There, at the Society of Artists, he began to exhibit landscapes. The first, which he showed in 1763, was *Mountainous Wooded Landscape with Horse Drinking* (fig.32). At five feet

square, it was among his biggest landscapes to date. Although it has strong affinities with the art of Ruisdael, the painting's rugged mountainous terrain and sweeping curves indicate the growing impact upon Gainsborough of Rubens and the French historical landscape painter Gaspard Dughet. At the same time that Gainsborough was looking at Van Dyck's portraits he was also paying close attention to Old Master landscapes in the same country house collections. While he clearly responded to the formal qualities of such works, their social cachet also impressed him. As he moved away from the shadow of the Dutch seventeenth-century masters towards their classical counterparts, Gainsborough's landscapes were increasingly removed, as Michael Rosenthal has observed, 'from the direct imitation of what was understood as nature at its least elevated to something rather more courtly and refined'.[13]

Gainsborough was a superb draughtsman. From the outset his technical skill and innovative approach to drawing had underpinned his landscapes in oils. As his oil paintings evolved so, by the later 1750s, his drawing style was changing as he liberated himself from the influence of the Dutch models that had guided his earlier work. Throughout his life Gainsborough drew directly from nature, although many of his surviving drawings were made in the studio (fig.33). In order to assist him, Gainsborough crafted lifelike models of animals and people from pieces of clay – something which he had done since his earliest days in London in the 1740s. He also made elaborate three-dimensional models at his home in Bath, on a special table reserved for the

33 *Wooded Landscape with Peasant asleep in a Cart* 1760s Watercolour and body colour with traces of pencil on brown paper 28.1 × 38 (11 × 15) Ashmolean Museum, Oxford

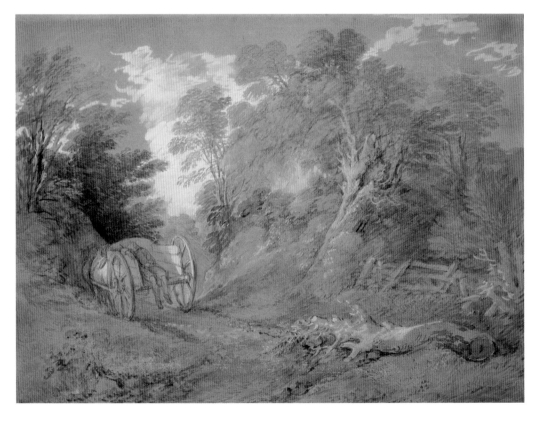

purpose. 'He would place cork or coal for his foregrounds; make middle grounds of sand and clay, bushes of mosses and lichens, and set up distant woods of broccoli.'[14] Reynolds, who referred to these models disapprovingly, noted how they were composed from 'broken stones, dried herbs, and pieces of looking glass, which he magnified and improved into rocks trees and water'.[15]

As interesting as Reynolds's account of the objects in Gainsborough's models is his reference to magnification. He may have meant merely that Gainsborough enlarged his models so that herbs became trees and stones were transformed into rock formations. It also raises the possibility that he had quite literally magnified his models, either by viewing them though a lens or even projecting them onto a two-dimensional surface. Although such practices were regarded as unconventional in Britain, they were commonplace among seventeenth-century Dutch painters, including Rembrandt and Vermeer. Gainsborough was an inveterate experimenter, and his later paintings upon glass (designed to be viewed under magnification) confirm his abiding fascination with the effects of optics and artificial light. While the rocks in Gainsborough's landscapes occasionally resemble pieces of coal, his models were perhaps made more to reveal the general qualities of light and shadow rather than to assist in the realisation of particular objects. Constructed in the evening, these models were designed to be viewed by candlelight. In 1763 Ozias Humphry noted that Gainsborough had already painted 'several landscapes of extraordinary Merit, that were mostly executed by Candle Light, to which he was much accustomed'.[16] Years later, Reynolds, who commented favourably upon Gainsborough's 'custom of painting by night', noted that by 'candle-light, not only objects appear more beautiful, but from their having a greater breadth and uniformity of colour, nature appears in a higher style'.[17]

In the spring of 1767 Gainsborough exhibited a landscape at the Society of Artists known as *The Harvest Waggon* (fig. 34). In this picture a young woman is hoisted into a waggon occupied by six figures organised in a pyramidal composition, the apex of which is formed by two young men fighting over a flask of liquor. Michael Rosenthal, who cites borrowings from pictorial sources as disparate as Hogarth, Raphael, Reynolds, and the classical statues of the horse-tamers on the Quirinal Hill in Rome, highlights the traditional identification of the young woman climbing into the waggon as Gainsborough's teenage daughter, Margaret. What, he wonders, is she doing 'adrift in a forest'?[18] Is she merely a model, or does her presence betoken something more personal? Other recent commentators, in accepting the proposal that Gainsborough's composition is adapted from Rubens's *Descent from the Cross*, have suggested that the picture 'discovers an image of the crucifixion in nature'.[19] To be sure, the picture contains a moral dimension: more precisely, it is a sophisticated and witty commentary upon the nature of sexuality and fertility – the central motif of the waggon once more serving as a symbol of the human passage through life. Gainsborough's landscape is an earthly paradise where moments of unbridled joy and gratification are succeeded by periods of introspection brought on by the burden of responsibility. This is made clear in Gainsborough's second version of *The Harvest Waggon* painted some twenty years later (fig. 35). Whereas the former work is structured as an ascent, in the

latter painting the principal movement is downwards. The man, who before was eagerly pulling the woman up, now bends forward; the rearing stallion now stands patiently by. The waggon, formerly the resort of lusty young hay-makers, is now laden with women, children, and babes-in-arms.

The later 1760s have been characterised as marking the onset of Gainsborough's 'Rubens phase', when the influence of that artist upon his landscapes predominated. As we have seen, this was brought about by the new opportunities he had to study Rubens's art, and to appreciate the elevated status in which the artist was held by wealthy collectors. In 1768, Gainsborough, who had clearly been looking closely at Rubens for some years, saw, perhaps for the first time, *The Watering Place* (fig. 36), then in the collection of the Duke of Montagu. At about the same time he was commissioned by Lord Shelburne to paint a landscape for Bowood, one of three pictures, as Shelburne recalled, 'intended to lay the foundation of a school of British landscapes'.[20] (The others were by Richard Wilson and George Barret.) In this, his most important landscape commission to date, Gainsborough modelled his painting *Peasants Returning from Market* (fig. 37) on Rubens, emulating his vivid colour and sinuous line. More than this, Gainsbrough was stimulated by Rubens's poetic

34 *The Harvest Waggon* 1767
Oil on canvas
120.7 × 144.8
(47½ × 57)
The Barber Institute of Fine Arts, University of Birmingham

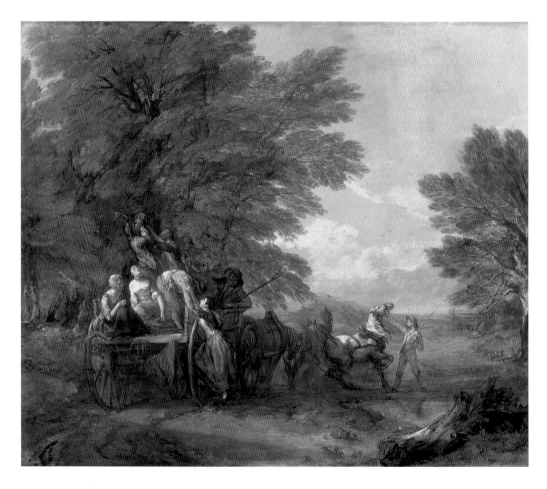

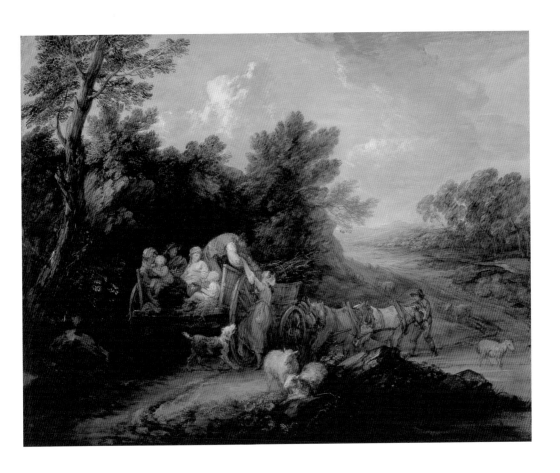

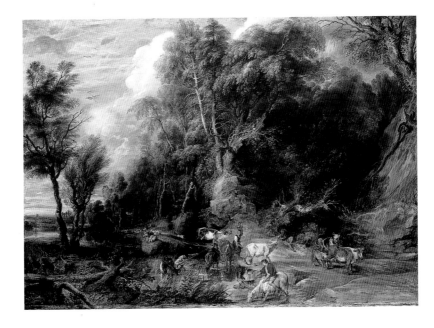

Above
35  *The Harvest Waggon* 1784–5
Oil on canvas
121.9 × 149.9
(48 × 59)
Art Gallery of Ontario, Toronto.
Gift of Mr and Mrs Frank P. Wood, 1941

Right
36  Peter Paul Rubens
*Peasants with Cattle by a Stream in a Woody Landscape: 'The Watering Place'* c.1620
Oil on oak panel
99.4 × 135
(39⅛ × 53⅛)
National Gallery, London

conception of rural life, even if his own account was less sanguine. Gainsborough depicts a group of mounted peasants wending their way through a wooded landscape. As they meander along, one man removes his hat to scratch his head – indicating his tiredness at the end of a day's labour. The picture is one of several painted by Gainsborough between the late 1760s and early 1770s featuring groups of peasants mounted on horseback, works which have collectively been described as 'an imagery of migration'.[21] This imagery does not, however, relate to the plight of displaced rural labourers, or the impact of economic transformations upon the English rural economy. Rather, it takes the form of a pictorial parable based upon the diurnal round of the peasantry, their transient joys and their stoic acceptance of hardship.

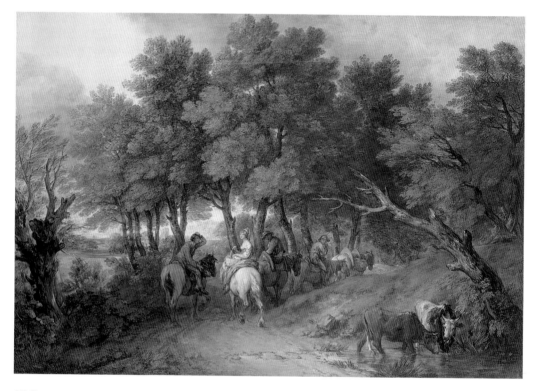

*37 Peasants Returning from Market Through a Wood c.*1767–8
Oil on canvas
121.3 × 170.2
(47¾ × 67)
Toledo, Ohio, Toledo Museum of Art; purchased with funds from the Libbey Endowment, Gift of Edward Drummond Libbey
Acc. 1955.221

# 4

# 'THOMAS GAINSBOROUGH, R.A.'

In 1777 Henry Bate-Dudley prefaced his review of the ninth annual exhibition of the Royal Academy with the banner headline 'Thomas Gainsborough, R.A.' 'As the pencil of this gentleman has evidently entitled him to the distinction,' he stated, 'we have impartially placed him at the head of the artists, whose works we are about to review.'[1] Bate-Dudley, however, knew that it was customary to begin any review of the annual exhibition with the Academy's president, Sir Joshua Reynolds. By flouting this unspoken rule he was throwing down a challenge to Reynolds's supporters. Four years earlier Gainsborough had withdrawn his paintings from exhibition following an argument with the Academy's Hanging Committee. Now he was to return to the fold, to threaten Reynolds's position within the Academy and as the country's premier painter. By this time Reynolds and Gainsborough, both founder members of the Royal Academy, had taken up very different positions within the institution. Reynolds was the Academy's spokesman; he guided its ethos and shaped its protocol. Gainsborough, meanwhile, sat on the sidelines, openly indifferent to Academy business, neglectful of his academic duties and scornful of Reynolds's quest for public acclaim and official honours. At the annual exhibition Gainsborough promoted his own pictorial strategies, which were quite at odds with the agenda adopted by the Academy's President. It was inevitable therefore that the two artists became arch-rivals. It had not always been that way.

Towards the end of November 1768 Reynolds wrote to Gainsborough inviting him to become a founder member of the Royal Academy. At this time Reynolds, following a period of indecision, had decided to throw in his lot with the Academicians, formed by a breakaway group from the Society of Artists. Gainsborough, too, had divided loyalties, as his close friend Joshua Kirby had recently been prevailed upon to become President of the Society. Despite his abiding reputation as a man guided by his feelings, Gainsborough was a pragmatist. The Royal Academy represented the future: it had, by and large, better artists, better opportunities for patronage and most importantly the ear of the King. Of the thirty-six original members of the Academy, only Gainsborough lived outside London. Even so, he had countless contacts in the capital and had exhibited there regularly since the early 1760s. His frenetic social life involved frequent London sojourns, including visits to concerts, theatrical performances and brothels. In 1763 he had contracted a sexual disease which not only resulted in a life-threatening illness, but the premature announcement of his death in a Bath newspaper. Despite such hazards, Gainsborough welcomed any excuse to visit London, and it was presumably with enthusiasm that he agreed to join the elite corps of Royal Academicians.

At the inaugural exhibition of 1769 he showed four pictures: two full-length portraits, a 'large landscape', and a 'boy's head'. As the description in the exhibition catalogue clearly indicates, the final picture was not a straightforward society portrait but a character study. Although it has never been identified, this picture may possibly have been a work known today as 'The Pitminster Boy' (fig. 38), which dates from the late 1760s. Nothing is known of this boy other than that he carried Gainsborough's brushes for him during sketching trips in Somerset. What better opening gambit at the Academy, therefore, than the portrayal of his assistant handing him his brushes? Of the two society portraits exhibited by Gainsborough, the first listed in the catalogue was a full-length portrait of Isabella, Viscountess Molyneux (fig. 39), commissioned to celebrate her marriage in December 1768. The pose is adapted from Van Dyck. Gainsborough's debt to the art of the past was, however, conditioned by his decision to portray the sitter in the height of contemporary fashion.

Reynolds's debut pictures in 1769 included two full-length portraits of female aristocrats swathed in classical drapery, *Lady Blake as Juno* (private collection) and *The Duchess of Manchester and her Son as Diana Disarming Love* (fig. 40), the figures' poses cribbed from the seventeenth-century Bolognese painter Francesco Albani. The contrast with Gainsborough underlines the marked opposition in their approaches to Grand Manner female portraiture. This was not a new departure. What did change was the way in which Reynolds justified his own portrait style through public lectures, the 'Discourses' which he delivered annually and later biennially at the Royal Academy. Gainsborough was perplexed by Reynolds's attempt in the early Discourses to colonise the intellectual high ground. 'Sir Joshua either forgets, or

Below left
38 *Unknown Youth, 'The Pitminster Boy'*
?c.1769
Oil on canvas
58.4 × 50.8
(23 × 20)
Private collection
on loan to
Gainsborough's House,
Sudbury, Suffolk

Opposite
39 *Isabella, Viscountess Molyneux, later Countess of Sefton* 1769
Oil on canvas
233.7 × 152.3
(92 × 60)
National Museums
and Galleries on
Merseyside (Walker
Art Gallery, Liverpool)

Below right
40 *Reynolds, The Duchess of Manchester and her Son as Diana Disarming Love* 1769
Oil on canvas
213 × 151
(83⅞ × 59½)
Wimpole Hall, The
Bambridge Collection
(The National Trust)

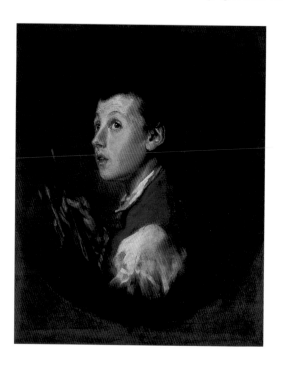

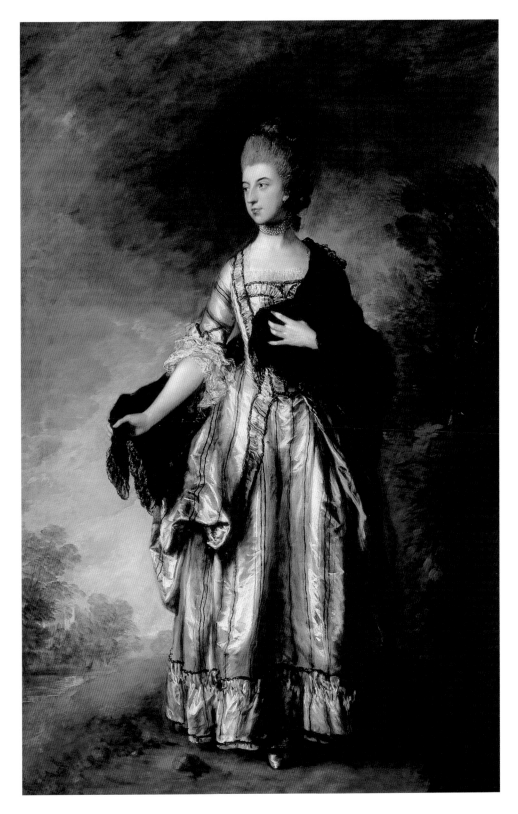

does not chuse [to] see that his Instruction is all adapted to form the History Painter, which he must know there is no call for in this country. The Ornamental Style (as he calls it) seems form'd for Portraits. Therefore he had better come <u>down</u> to <u>Watteau</u> at once ... and let us have a few Tints.'[2] Gainsborough must have felt particularly aggrieved at the President's words, since his own works were painted in the 'Ornamental Style' – a style which emulated the dazzling colour and bravura handling of the Venetian school, and acolytes such as Rubens, Van Dyck and Watteau. Gainsborough, characteristically, had no desire to theorise his own approach, cheerfully affirming that 'there is no other Friendly or Sensible way of settling these matters except upon <u>Canvass</u>'. He had perhaps already attempted to 'settle the matter' in 1770 at the Royal Academy with the portrait of 'a young gentleman', almost certainly the picture known today as *The Blue Boy* (fig.41).

*The Blue Boy* is Gainsborough's most famous picture, and his most enigmatic. Through its elevation to iconic status in the twentieth century this picture, more than any other, has served to promote the artist's image as a romantic painter of chocolate-box cavaliers. Nothing could be further from the truth. The painting is a parody. The boy in question was not the offspring of an aristocrat but the teenage son of a prosperous Soho ironmonger, and a personal friend of the artist. His costume was a popular form of fancy dress which, although Reynolds had used it regularly in portraits, was otherwise restricted to the ephemeral realm of the masquerade, then a popular form of entertainment in the capital. Gainsborough had a dim view of what he termed 'the foolish custom of Painters dressing people like scaramouches'.[3] X-rays have revealed that Gainsborough painted *The Blue Boy* upon a discarded, cut-down canvas, which further suggests that this was not a straightforward portrait commission but an impromptu *jeu d'esprit*.[4] By mischievously including it among his society portraits at the 1770 exhibition Gainsborough clearly sought a reaction. Gainsborough's old mentor, Francis Hayman, considered the picture to be 'as fine as Vandyke'.[5] Indeed, it appears to have made the greatest impression upon Gainsborough's fellow artists – who also coined the popular sobriquet by which the picture became known. Shortly after his death it was stated that Gainsborough had painted *The Blue Boy* as a challenge, a proposition supported by the arrogant swagger of the picture's subject. This in turn gave credence to the story that Gainsborough wished to confute Reynolds's assertion that 'cold' colours, such as blue, ought never to be used for the principal subject in a composition. Such a proposition is undermined not only by the fact that Reynolds did not make this assertion until later in the decade, but also by his willingness to paint figures in blue draperies – although he does appear to have avoided Van Dyck costume for a while. Gainsborough's picture, whatever else it did, clearly offered a challenge, not just to Reynolds, but to every one of his fellow portrait painters, to match his own virtuosity.

Gainsborough's idiosyncratic approach to portrait conventions surfaced in other submissions to the Academy exhibition at that time. They included his full-length of Penelope, Viscountess Ligonier (fig.42), painted in the summer of 1770 at her father's seat at Stratfield Saye, Hampshire, and exhibited at the

41 *Jonathan Buttall: 'The Blue Boy'* c.1770
Oil on canvas
117.8 × 121.9
(70 × 48)
Huntington Library, Art Collections, and Botanical Gardens, San Marino, California

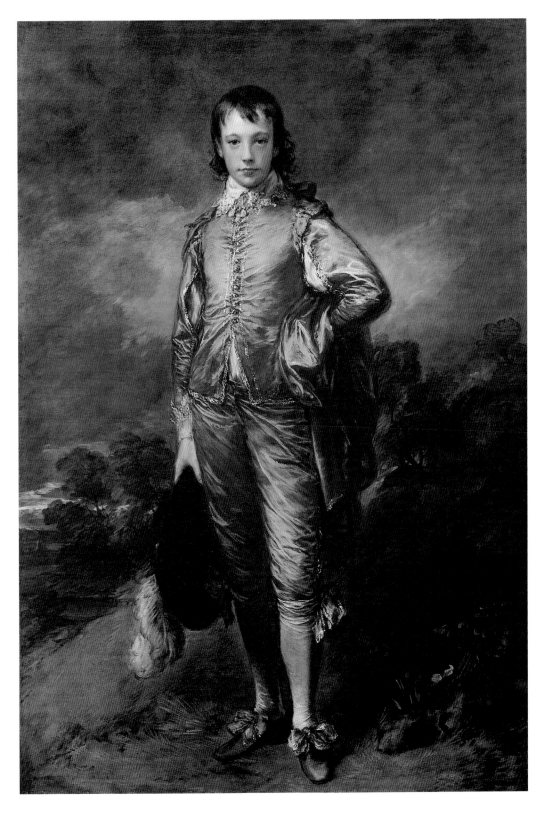

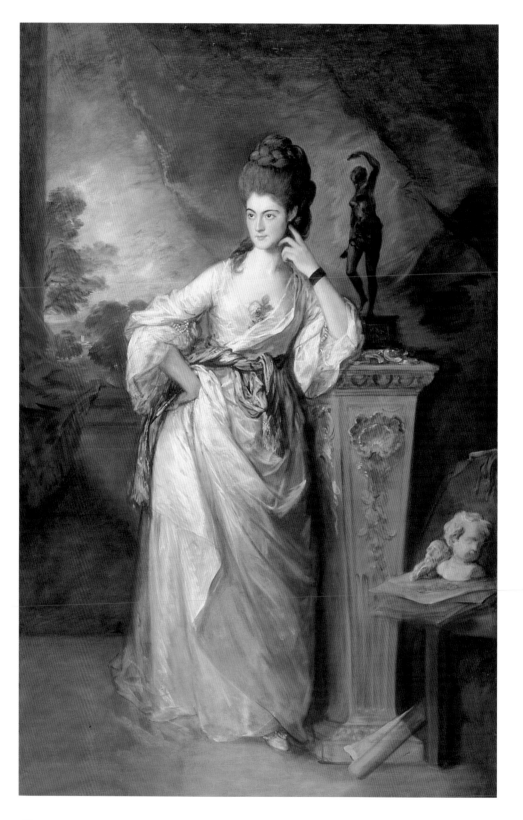

Academy the following year. Here Gainsborough adopts the classical image promoted by Reynolds in his own female portraiture: the employment of 'timeless' draperies, the ornamented pedestal and antique statuary. This portrait is not, however, merely decorative. Penelope Pitt, whose father was a close friend of Gainsborough, was a colourful character with a reputation as a 'man eater'. She is not presented in the guise of a muse or handmaiden, but as a formidable flesh-and-blood presence. The drawing implement which she clutches in her right hand is less an emblem of gentility than a potential weapon, the dancing bacchante beside her a teasing commentary, possibly, on her own free-spirited nature. As with *The Blue Boy*, this portrait exudes an air of confrontation, her piercing gaze and uncompromising body language proclaiming her independence. It is therefore not surprising to learn that, at the very time her portrait was on show at the Royal Academy, Lady Ligonier, who had already had an affair with her husband's postilion, was being tried as an adulteress, following a torrid affair with a young Italian ensign.[6]

At the Academy Gainsborough preferred to exhibit full-length portraits rather than works of a more modest scale, conscious, as he told a client, that 'half lengths are overlook'd in such a Monstrous large Room and at a Miles Distance'.[7] He did, however, exhibit landscapes; in 1772 he showed no fewer than ten landscape drawings in imitation of oil painting. They may have included the large monochrome drawing in watercolour and oil depicting a wooded landscape with mounted peasants (fig.43). This drawing, made upon six separate sheets of paper pasted together and varnished, is far more classical than Gainsborough's landscapes of the 1760s, and is influenced by Poussin and Gaspard Dughet. Gainsborough's reason for exhibiting such works, as Michael Rosenthal has stressed, may have been to subvert conventional 'academic theories about the propriety of genres and media', since it was the norm to promote history painting and portraiture over landscape, and oil painting over watercolour and drawing.[8] Gainsborough was clearly determined that his landscapes should not be overlooked. 'I am', he had admitted in 1771, 'daubing away for the Exhibition with all my might, and have done two Landskips which will be in two handsome frames.' They were,

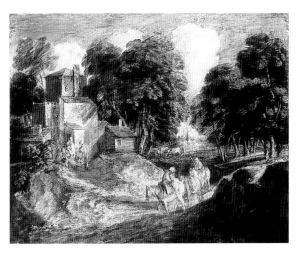

43 *Wooded Landscape*
*with Mounted*
*Peasants c.*1771–2
Gouache on paper
mounted on canvas
100.3 × 128
(39½ × 50⅜)
Indianapolis
Museum of Art, Gift
of Mrs Nicolas H.
Noyes

he added, 'the best I ever did, & probably will be the last I shall live to do'.[9] These landscapes have never been identified, although they were by no means the last that Gainsborough would do, despite increasing pressure to concentrate his energies upon commissioned portraits.

For many years Gainsborough had impressed upon clients that his paintings should be shown to their best possible advantage, at the correct height and in the appropriate lighting conditions. He was therefore incensed at what he saw as the cavalier attitude displayed towards his exhibits by the Hanging Committee of the Royal Academy. As a result, in 1773 he declined to exhibit at all, telling his friend, the actor David Garrick: 'they hang my likenesses too high to be seen, & have refused to lower one sail to oblige me.'[10] Gainsborough's decision to stop exhibiting was not regarded as a sign that he had severed his ties with the Academy completely; and in December 1774 he was elected to the Council. A year later it was resolved that he should be removed from his post, since he had never attended a single meeting. Surprisingly, perhaps, the resolution was overruled. None the less, there is no indication that Gainsborough ever made any effort to improve his attendance record – although he did turn up to the Academy dinner in 1788.

The decision to appoint Gainsborough to the Academy's Council, a position held by rota, may also have been prompted by his move to London in the summer of 1774. Although it has often been suggested that his decision to leave Bath was impromptu (Philip Thicknesse attributing it to a quarrel between the two of them) he may have entertained the possibility for a year or so. It was particularly convenient for him to move in 1774, as this coincided with the end of the seven-year lease on one of his two houses in Bath.[11] In London, Gainsborough leased the west wing of Schomberg House, an imposing residence on Pall Mall, near the Court of St James's. Here he constructed a large painting room over the garden and a gallery to display his works. Since Gainsborough was not then exhibiting his works in London he may have felt an even more pressing need to impose his personal presence in the capital: that he did so in such an ostentatious manner underlines the extent of his professional and social ambitions.

The majority of Gainsborough's wealthy patrons had London residences. Many of his friends also lived there. His move to London coincided with an auspicious moment for two of his closest companions, the musicians Carl Friedrich Abel and Johann Christian Bach, who in February 1775 launched their celebrated subscription concerts in Hanover Square. Gainsborough was intimately involved in this venture, devising a large transparent Comic Muse, lit from behind with candles. He also painted portraits of Bach and Abel. The full-length portrait of Abel (fig.44) was evidently a flattering likeness, since Abel was quite corpulent. Yet, while Gainsborough could joke to friends about 'Abel's fat Guts', the portrait reflects his friend's refined sensibility and taste. Here he is shown in the act of composing, his quill poised over a sheet of music, his mind alert with ideas.[12] Years later upon hearing of Abel's death Gainsborough wrote feelingly: 'For my part I shall never cease looking up to heaven ... in hopes of getting one more glance of the man I loved from the moment I heard him touch the string.'[13]

44 *Carl Friedrich Abel* 1777
Oil on canvas
223.5 × 147.3
(88 × 58)
Huntington Library, Art Collections, and Botanical Gardens, San Marino, California

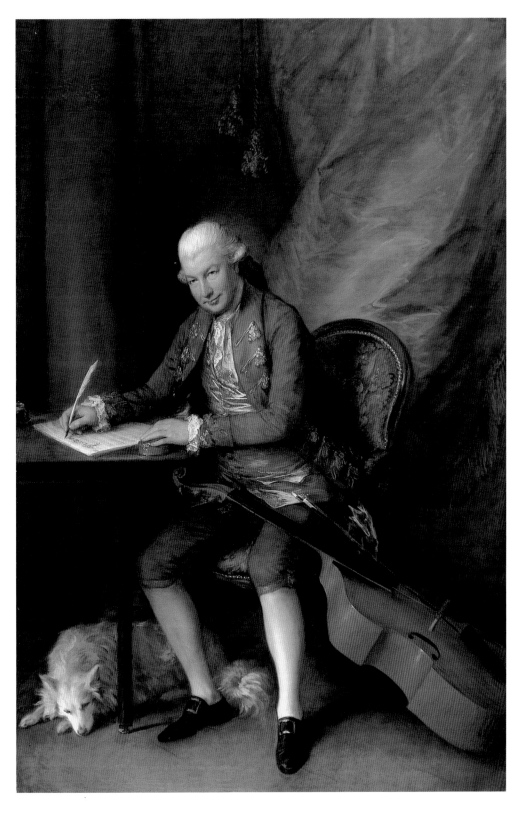

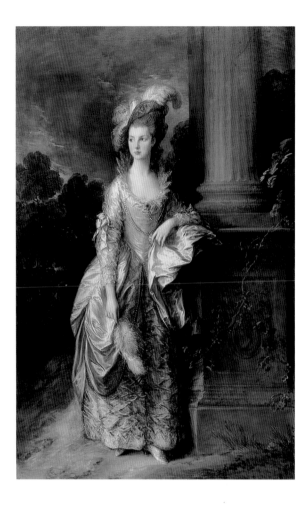

45 *The Hon. Mrs Graham* 1777
Oil on canvas
237.5 × 154.3
(93½ × 60¾)
National Gallery of
Scotland

The portrait of Abel was one of seven paintings exhibited by Gainsborough in 1777. Of these, six were portraits, including *The Hon. Mrs Graham* (fig.45). According to tradition this portrait was painted on Mrs Graham's honeymoon, early in 1775, when she and her husband were living in London. As with *The Blue Boy* the pose is borrowed from Van Dyck. Her flamboyant costume is a so-called 'Vandyke dress', then popular at masquerades, although it is actually derived from the celebrated portrait by Rubens of his wife Helena Fourment, then usually attributed to Van Dyck.[14] The picture, like *The Blue Boy*, exemplifies Gainsborough's 'Ornamental Style'. It also pays tribute to Reynolds's recent evaluation of Van Dyck as 'the first of portrait painters'.[15] *The Hon. Mrs Graham* displayed Gainsborough's allegiance to Van Dyck. At the same time it proclaimed that he, rather than Reynolds, was the true heir to the tradition established by Van Dyck.

Gainsborough and Reynolds, in common with their fellow society portrait painters, were intent upon promoting their careers through the celebrity of the subjects they exhibited at the Academy. In this respect, Reynolds had led the way earlier in the decade by exhibiting a succession of famous faces: authors, actors, politicians and grandees – the cream of the Georgian

'glitterati'. If he was to succeed at the highest level, Gainsborough, too, had to play this game. He did so with relish, putting off less glamorous sitters in order to court celebrity. Among the most alluring subjects for the Academy audience were courtesans, actresses and performers, to whom posing came as second nature. They included the Italian ballerina Giovanna Baccelli, whose portrait Gainsborough exhibited at the Royal Academy in 1782 (fig.46). Baccelli was the mistress of the Duke of Dorset. In addition to the present portrait, he commissioned a life-size nude statue of her reclining on a couch in the attitude of the celebrated classical sculpture, the Borghese *Hermaphrodite*. In Gainsborough's portrait she appears in her professional guise, performing the part she danced at the King's Theatre the previous season. Baccelli wears heavy make-up, with rouged cheeks, a form of personal display associated with courtesans and other disreputable women.[16] Although some moralists disapproved of such works (Baccelli was after all a mere 'performer') portraits like this placed Gainsborough firmly in the public spotlight and propelled him further into the most influential circles of aristocratic patronage.

Gainsborough's return to the Royal Academy exhibition in 1777 included his largest landscape to date, *The Watering Place* (fig.47). This highly ambitious

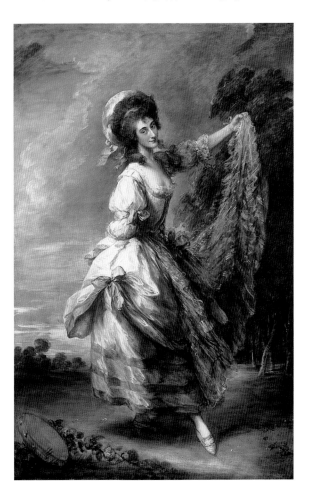

46 *Giovanna Baccelli*
1782
Oil on canvas
230.6 × 151.2
(91¼ × 60½)
Tate

work measures nearly five feet by six feet – bigger than Constable's celebrated 'six-footers' of the 1820s. The sheer scale of the picture emphasised Gainsborough's determination to maintain his public reputation in both genres. As the *Public Advertiser* stated: ''Tis hard to say in which branch of the art Mr Gainsborough excels, landscape or portrait painting.'[17] The picture was also eulogised by the celebrated aesthete and author, Horace Walpole, who wrote in his exhibition catalogue that it was in 'the Style of Rubens, & by far the finest Landscape ever painted in England, & equal to the great Masters'.[18] He was not alone in making the connection with Rubens. Gainsborough may have been influenced by Rubens's *The Watering Place* (see fig. 36). The differences between the two compositions are as striking as the similarities, as Rubens's energetic, sinewy landscape contrasts markedly with Gainsborough's soft-focused, pastoral idyll. Yet, while a more appropriate stylistic comparison might have been made with the landscapes of Gaspard Dughet, Gainsborough's *The Watering Place*, as contemporaries were aware, was not to be evaluated simply by reference to pictorial precedents.[19] Both in terms of colour and handling it represented something quite new. As one critic remarked: 'The Scene is grand; the Effect of Light is striking; the Cattle very natural: but what shall I say of the Pencilling? I really do not know; it is so new, so very original, that I cannot find Words to convey any Idea of it.' Reference

47 *The Watering Place* 1777
Oil on canvas
147.3 × 180.3
(58 × 71)
National Gallery,
London

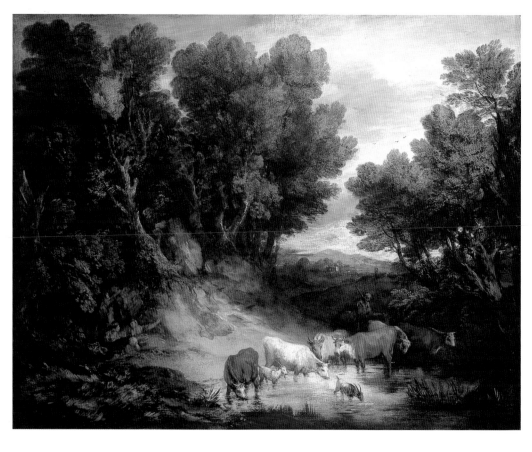

to the external world is subjugated to Gainsborough's overriding concern with colour and effect, and with the abstract potential of paint. The picture was subversive, even dangerous. 'I do not know that any Artists,' concluded the critic, 'living or dead, have managed their Pencil in that Manner, and I am afraid that any Attempt to imitate it will be attended with ill-success.' [20]

By the late 1770s the audience for public exhibitions had grown enormously. From around 14,000 visitors in 1769 the total number of visitors to the annual Royal Academy exhibition had risen to over 60,000 by 1780, the year in which it transferred to prestigious premises at New Somerset House. The surge in interest in contemporary art had, in turn, led to a tide of art criticism, occupying countless column inches in the daily press. Before the intervention of the Reverend Henry Bate-Dudley in 1777, Reynolds had been largely unchallenged as the country's leading artist. Now Gainsborough had a formidable mouthpiece: Bate-Dudley's journalistic prowess was matched by his skills as a pugilist – for which he was nicknamed 'The Fighting Parson'.[21] His acerbic criticism did not just focus upon the superiority of Gainsborough's art but his alleged mistreatment by the Academy's Hanging Committee. In 1777 Bate-Dudley, then editor of the *Morning Post*, hailed *The Watering Place* as

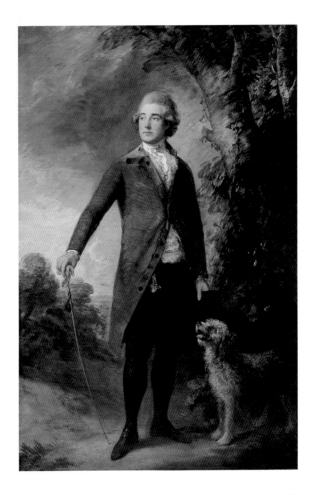

48 *The Revd Sir Henry Bate-Dudley* 1780
Oil on canvas
223.5 × 149.9
(88 × 59)
Burton Property Trust, on loan to Tate

'a master-piece of its kind': but, he added, it 'is viewed to every possible disadvantage from the situation in which the directors have thought proper to place it'.[22] The following year he defended Gainsborough against attacks upon his 'unnatural' colour and lack of finish. 'Gainsborough,' he stated, 'has been reproached with negligence in finishing. If his pieces be view'd at a proper distance, which as it is manifestly his design is the only just way of estimating their merit, this imputation will appear totally without foundation.' To rub it in, he crowned Gainsborough the 'Apollo' of the Royal Academy, 'not excelled by Sir Joshua Reynolds'.[23] In 1780, at the inaugural exhibition at New Somerset House, Gainsborough exhibited Bate-Dudley's portrait (fig.48), his defiant posture, no doubt, deliberately echoing his combative stance with respect to Gainsborough's art. The Hanging Committee placed the picture next to Henry Fuseli's *Satan Starting from the Touch of Ithuriel's Lance*, which was flanked on the other side by John Singleton Copley's portrait of a Highland officer. 'We have more reason than one,' observed a reviewer, 'to fancy there was a little playful spark of satire in the arrangement of the pictures; it would not trust the Devil between any but the Highlander and Mr. Bate.'[24]

In 1781 Gainsborough exhibited seven works at the Academy, including portraits of King George and Queen Charlotte and a character study of a shepherd boy. The *Shepherd Boy* (known today only through an engraving (fig.49)) heralded a new departure in Gainsborough's public art. The picture, with its quasi-religious aspect, was clearly inspired by the example of the seventeenth-century Spanish artist Bartolomé Esteban Murillo, whose paintings of beggar boys currently enjoyed a considerable vogue. Bate-Dudley praised the picture and hailed Gainsborough as 'the principal support of the present exhibition'.[25] Reynolds's acolytes poured scorn upon this assertion, promoting the President's claim by virtue of his intellectual and ideological superiority. Reynolds's own contributions that year included several specimens of high art. Even his elevated portraits were 'in a line of art which the vaunted painter of the King and Shepherd must never hope to obtain'. Gainsborough's name, 'however honourable in its rank', was, the same critic affirmed, simply 'not great enough to head a class, or to be often repeated by posterity'.[26] By now the convergence of Reynolds's ambitions and the institutional aims of the

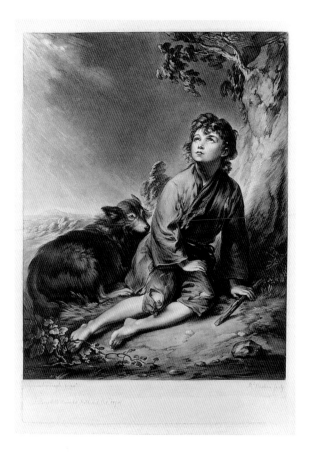

49 Richard Earlom, after Thomas Gainsborough *A Shepherd Boy* 1781 Mezzotint 40.1 × 27.9 (15¾ × 11) Gainsborough's House, Sudbury, Suffolk

Academy were confirmed in the public eye. He was, at least in the eyes of his supporters, a 'class' above Gainsborough.

Reynolds could now afford to be generous to his rival: in 1782 he purchased Gainsborough's *Girl with Pigs* (fig.50), which he had exhibited at the Royal Academy that year. Contemporaries would have described the *Girl with Pigs* as a 'fancy picture'. The roots of this genre were to be found in seventeenth-century continental art, notably in the Low Countries, where such pictures often illustrated a proverb or popular saying. More recently it had been revived by Reynolds in a series of paintings of children, often depicted in the guise of infant saints and deities. They included *The Infant Samuel* (fig.51), among the most popular of his works in this genre. Like *The Infant Samuel*, the *Girl with Pigs* also appealed to the traditions of sacred art; here, through an oblique reference to the biblical story of the Prodigal Son feeding swine.[27] Gainsborough had valued the work at sixty guineas. Reynolds paid him one hundred and hung it in his picture gallery among his collection of Old Masters. Bate-Dudley was unimpressed. 'Why does Sir Joshua hang Mr. Gainsborough's little picture of the pigs in his cabinet collection of all the greatest masters of past times? Does Sir Joshua really intend this as a compliment to his

50 *Girl with Pigs*
1782
Oil on canvas
125.6 × 148.6
(49½ × 58½)
Castle Howard
Collection

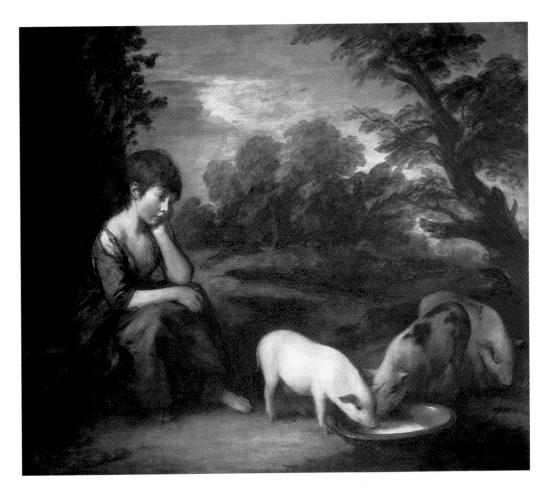

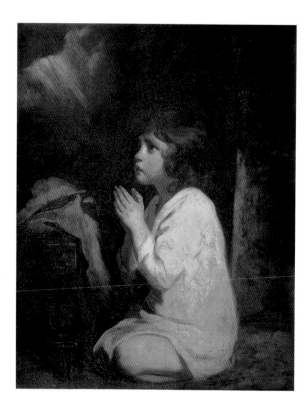

contemporary, or is it to afford room for invidious comparison?'[28] Gainsborough professed to be flattered, telling Reynolds, 'I may truly say that I have brought my Piggs to a fine market.'[29] A few years later Reynolds patronisingly remarked to a friend that it was 'by far the best Picture he ever Painted or perhaps ever will'.[30] He subsequently sold it for three times the sum he had originally paid Gainsborough.

Reynolds's purchase of the *Girl with Pigs* paved the way for a thawing of relations between the two artists: the following autumn they agreed to paint one another's portraits. Unfortunately, after he had sat only once to Gainsborough Reynolds was taken ill and the project was abandoned. They did not meet again until Reynolds visited Gainsborough on his deathbed. In the mean time Gainsborough had all but abandoned the Academy for the Court.

# 5

# 'THE APOLLO OF THE PALACE'

In 1781 Gainsborough exhibited portraits of George III and Queen Charlotte at the Royal Academy. The King is portrayed outdoors, dressed in the Windsor uniform, an off-duty outfit he had designed for family and friends. The Queen (fig.52), wears a spangled gown and floral head-dress, a 'pairing of woman and fairy queen'.[1] In this portrait, completed at breakneck speed, Gainsborough makes no effort to conceal his art, allowing the viewer's imagination to supply details which are suggested rather than described. Reynolds's pupil, James Northcote, recalled that Gainsborough and his nephew, Gainsborough Dupont, had painted the drapery in a single night: it exemplified, he added waspishly, the 'essence of genius, the making of beautiful things from

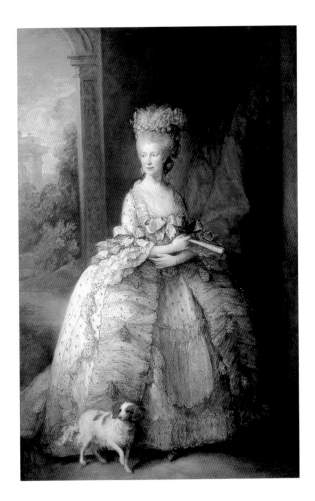

52  *Queen Charlotte*
1781
Oil on canvas
238.8 × 158.7
(94 × 62½)
The Royal Collection,
Her Majesty Queen
Elizabeth II

unlikely subjects'.² By now Gainsborough was on familiar terms with the royal family. 'With all his apparent carelessness Gainsborough knew mankind well & adapted himself to their humour, when He thought it worth while. He said to [Francis] Bourgeois, "that he talked bawdy to the King, & morality to the Prince of Wales".'³ In 1778 Bate-Dudley had referred to Gainsborough as the 'Apollo' of the Royal Academy. Now that he was 'quite established at Buckingham House', he was 'the Apollo of the Palace'.⁴

Gainsborough may initially have been introduced to the King by Joshua Kirby, royal drawing master since his arrival in London in the mid-1750s. Until his death in 1774, Kirby lived near the royal residence at Kew Palace, where he was employed as Clerk of Works at Richmond Gardens. Gainsborough, who often stayed with Kirby in Kew, now acquired his own residence in Richmond,

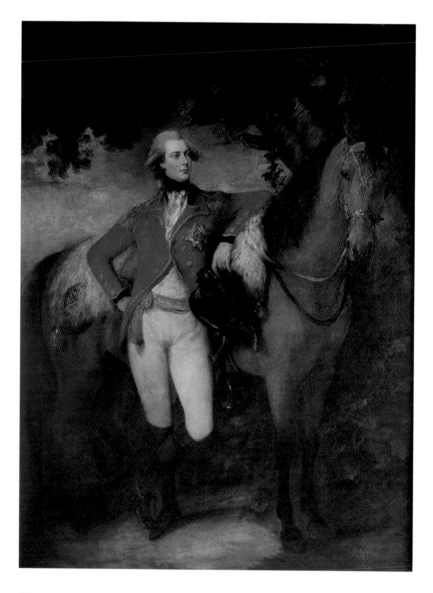

53 *George, Prince of Wales* 1782
Oil on canvas
228.6 × 208.3
(90 × 82)
Waddesdon Manor,
The Rothschild
Collection (The
National Trust)

where the King was in the habit of visiting him.[5] This casual arrangement must have appealed to Gainsborough, especially since the official post of Principal Painter to the King – then held by the Scottish artist, Allan Ramsay – had been reduced to a meaningless sinecure. By now Ramsay was virtually retired. Reynolds, as President of the Royal Academy, coveted the post. The King disliked him, partly on personal grounds, and partly because of his affiliation to the Rockinghamite Whigs, who formed the principal opposition to the Court party. Despite this enmity, Reynolds ensured that he was made Principal Painter to the King on Ramsay's death in 1784. Because of his royal connections Gainsborough also expected to get the job: he told Lord Sandwich that he was 'very near being King's Painter only Reynolds's Friends stood in the way'.[6]

Gainsborough was patronised liberally by other royals, besides the King. George, Prince of Wales, was an enthusiastic if wholly unreliable patron of the arts. He purchased portraits and a couple of Gainsborough's landscapes, including a second version of *The Harvest Waggon* (see fig.35), which he bought in 1786. The Prince had ambitious plans for his extravagant new residence, Carlton House, including a series of portraits by Gainsborough of family and friends. These plans amounted to little, and left Gainsborough with unfinished canvases and, as usual with the Prince, a pile of unpaid bills. Among those works completed for the Prince were portraits of his erstwhile mistress, Mary Robinson (Wallace Collection), and his own full-length portrait (fig.53), which Gainsborough exhibited at the Royal Academy in 1782. Still only aged twenty, the Prince was eligible and reasonably good-looking: he was also a consummate fantasist, with a passion for dissembling, intrigue and dressing up. Gainsborough's portrait depicts him in a uniform of his own invention, since at that time he did not hold any sort of military commission.

In 1783 Gainsborough exhibited a group of fifteen portraits of the royal family at the Royal Academy (fig.54). These portraits were conceived by George III as a kind of family album; a vain attempt to provide an aura of unity at a time when his eldest son was increasingly embittered and estranged from his parents. Gainsborough hugely enjoyed the commission, which he carried out at Windsor in the autumn of 1782. In particular, he relished painting the younger children, reportedly being 'all but raving mad with ecstacy in beholding such a constellation of youthful beauty'.[7] The small oval format Gainsborough employed in these works is reminiscent of the portrait miniature, a comparison which underlines their intimacy. Gainsborough issued written instructions to the Hanging Committee on how these works were to be displayed, and even included a diagram. To ensure compliance he swore an oath: 'if The Royal Family, which he has sent for this Exhibition, (being smaller than three quarters) are hung above the line along with full lengths, he never more, whilst he breaths, will send another Picture to the Exhibition – This he swears by God.'[8] The Committee abided by his edict – perhaps out of respect for the King, or because the portraits were individually small pictures, even if mounted as a group. The following year Gainsborough repeated his demand, this time over a group portrait of the three eldest princesses commissioned by the Prince of Wales for Carlton House. The Hanging Committee refused possibly because this was unequivocally a large picture and definitely

54 *The Royal Family*
[group of fifteen oval
portraits] 1783
Oil on canvas
each *c.* 59 × 44
(23¼ × 17⅜)
The Royal Collection,
Her Majesty Queen
Elizabeth II

broke the hanging rule. Gainsborough demanded the return of all his works
from the exhibition. Two weeks later the Academicians invited the Prince of
Wales as guest of honour at their annual pre-exhibition dinner. He made them
wait for an hour and a half before sending word that he was occupied else-
where. Gainsborough, too, was henceforth conspicuous by his absence.

By the early 1780s numerous shows vied for the public's attention in the
capital. They included the so-called *Eidophusikon*, created in 1781 by Gains-
borough's friend, the artist Philip de Loutherbourg (although they fell out
soon afterwards). This theatrical spectacle involved the simulation of storms
and shipwrecks. At the same time Gainsborough devised his own 'peep-show'
box for viewing paintings on glass (fig.55).⁹ The paintings, designed to be
viewed under magnification by candlelight, were rapidly sketched, some in the
course of an evening. Although Loutherbourg may have provided the imme-
diate inspiration, the transparencies also recalled Gainsborough's earlier
three-dimensional models and his transparencies for Bach and Abel. The glass
paintings were not just entertainment but a further means of exploring
pictorial light. As his experiments with drawing techniques and printmaking
indicate, Gainsborough was also concerned to erode the barriers that under-
pinned current artistic hierarchy, where oil paint and high art were the
primary means of conveying a serious moral purpose.

Gainsborough never visited Italy. None the less, his reputation as an insu-
lar artist – however lauded in the Victorian era – is undeserved. He travelled to
Flanders in 1783.¹⁰ This is the only trip to the Continent we know about,
although it may not have been the first time he had visited the Low Countries.
During the late 1770s and early 1780s Gainsborough travelled around Britain,
perhaps prompted by an increasing desire to escape the claustrophobic en-
vironment of the metropolis. In the summer of 1779 he proposed to spend at

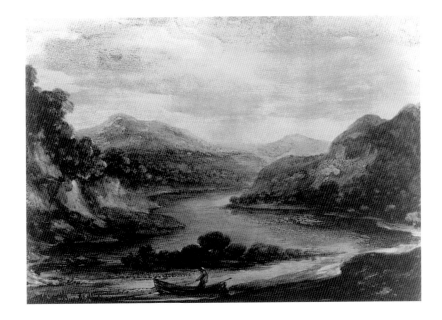

55 *Wooded River Landscape with Fishermen in a Rowing Boat, High Banks and Distant Mountains* c.1783–4
Transparency on glass
27.9 × 33.7
(11 × 13¼)
Victoria and Albert Museum, London

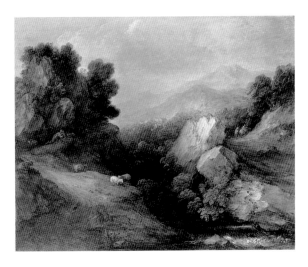

56 *Rocky Wooded Landscape with Dell and Weir, Shepherd and Sheep on a High Bank, Mounted Peasant and another Figure, and Distant Village and Mountains*
1783
Oil on canvas
116.2 × 143.5
(45¾ × 56½)
National Gallery of Scotland

least a month sketching on the south Devonshire coast. Two years later at the Royal Academy he exhibited a coastal scene, which was described by Horace Walpole as 'so free and natural, that one steps back for fear of being splashed'.[11] Around 1782 he toured the West Country and the Wye valley with Gainsborough Dupont. He probably also visited Wales. In the summer of 1783 he travelled to the Lake District, telling a friend that he was going to display pictures of 'all the Lakes at the next Exhibition, in the great Stile'.[12] Among the first of his pictures to focus upon dramatic mountainous scenery was a large mountain landscape (fig.56), exhibited at the Academy in 1783. This picture may have been inspired by his direct experience of Welsh landscape – as well as the 'sublime' landscapes of Claude Lorrain and Gaspard Dughet.

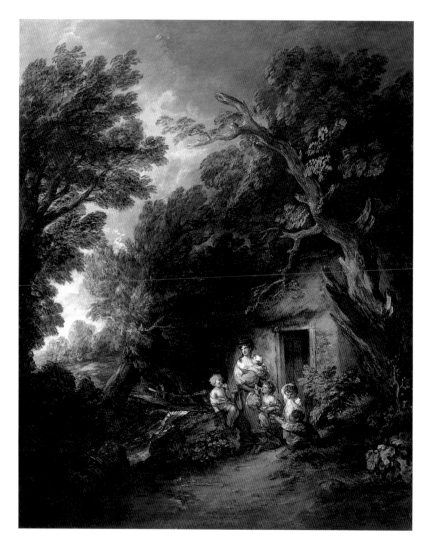

57 *The Cottage Door*
1780
Oil on canvas
147.3 × 119.4
(58 × 47)
Huntington Library,
Art Collections, and
Botanical Gardens,
San Marino,
California

Since his return to the Royal Academy exhibition, most of the works Gains-
borough exhibited had been portraits. Between 1777 and 1779 he showed
twenty-two portraits but only four landscapes, an indication of his intention
to compete head to head, as it were, with Reynolds. In 1780, however, Gains-
borough showed six landscapes, including a work known as *The Cottage Door*
(fig.57). This masterly composition is made up of a series of overlapping
pyramidal constructions, beginning with the group of figures and carrying
up through the picture to the overarching tree branches and foliage. The Cot-
tage Door was a genre he turned to frequently over the next few years. Perhaps
these pictures provided a means of escape from the stresses of his professional
life, or his unhappy domestic circumstances, or an emotive response to rural
poverty and displacement apparent in the recent poetry of Goldsmith and
Crabbe.[13] However that may be, there is no indication that the iconography of
these pictures was remotely troubling to Gainsborough's contemporaries:
quite the reverse. As one writer observed: 'serenity and pleasure dwell in every

spot, and the lovely figures composed in the finest rural style, their situation worthy of them, forms a scene of happiness that may truly be called Adam's paradise.'[14]

Gainsborough had painted his first Cottage Door in 1772, a picture known as *The Woodcutter's Return* (fig.58). To the modern viewer the picture may appear to highlight the predicament of the peasant family with its many mouths to feed. But at the time it was celebrated in verse as 'a scene of beauty, and domestic love'.[15] Its bucolic air (not to mention the glazed windows of the cottage) had less in common with rural hovels than the cottage orné then being constructed in the grounds of Richmond Gardens (now Kew) for Queen Charlotte. The picture's idyllic aspect, and its obvious connection with this modish domestic architectural style, may also explain its attraction for Charles Manners, later 4th Duke of Rutland, the 'noble lord' who purchased it. By 1780 Gainsborough habitually viewed the countryside from the vantage point of his villa in Richmond and the 'cottage' he visited from time to time on

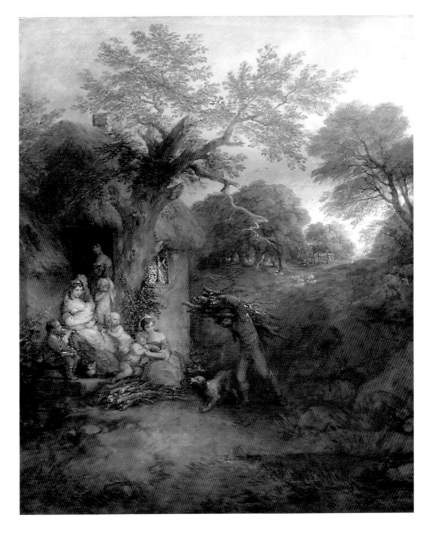

58 *The Woodcutter's Return* 1772–3
Oil on canvas
147.3 × 123.2
(58 × 48½)
His Grace the Duke of Rutland, Belvoir Castle

Henry Bate-Dudley's country estate in Essex. Contemporaries report that the sight of the rural poor moved Gainsborough. While his compassion is not in doubt, his response was couched primarily in aesthetic terms. Like the poet Crabbe, and many others at the time, it would seem that Gainsborough's attitude to the labouring poor was, as John Barrell says, that 'we may pity them, but should not suggest that they are capable of being anything else'.[16]

In the winter of 1783 Gainsborough painted a picture now known as *The Mall* (fig.59). At the time George III was rumoured to have commissioned the picture, although this propaganda may have been generated by Gainsborough, since the King's interest in him appears to have waned by this time. The picture remained unsold during the artist's lifetime. That it had been calculated to appeal to the King is suggested by Henry Bate-Dudley's comment that it 'strikes a spectator as tho' the objects were surveyed from Buckingham-house'.[17] Like Gainsborough's house in Pall Mall, Buckingham House commanded an excellent view of The Mall, then among the most fashionable spaces to see and be seen in. In Gainsborough's picture, this is a resolutely female dominion, where women of the *demi-monde* exchange glances and compete for the attention of male lovers who loiter in the shadows. In its

59 *The Mall* 1783–4
Oil on canvas
120.6 × 147
(47½ × 57⅞)
The Frick Collection, New York

depiction of the stylised rituals of cosmopolitan courtship, *The Mall* is completely antithetical to the domestic virtues celebrated in Gainsborough's 'Cottage Door' scenes. Yet the two worlds do have something in common, for, as it has been noted, the mannikins who promenade through *The Mall* are little more than 'the fashionably dressed equivalents of those in his "Cottage Door" scenes'.[18] They represent, perhaps, sides of the same coin, *The Cottage Door* inviting repose and contemplation, *The Mall* buzzing with incessant movement and gossip. As the artist James Northcote observed some years later, 'it is all in motion, and in a flutter like a lady's fan'. 'Watteau,' he added, 'is not half so airy.'[19] Gainsborough, who had developed a love of Watteau during his teenage years in St Martin's Lane, was clearly inspired by him once more. Like Watteau, he enjoyed the interplay between artifice and reality, between theatre and life. Nor did *The Mall*, like Watteau's *fêtes galantes*, conform to any traditional academic genre. Watteau was, of course, the artist whose 'French Gallantries' Reynolds had dismissed some fifteen years earlier as an inferior genre, and which had in turn prompted Gainsborough's suggestion that the President should get off his high horse and 'come <u>down</u> to <u>Watteau</u>'.[20]

*The Mall* was one of twenty-five pictures which Gainsborough displayed in July 1784 at his inaugural exhibition at Schomberg House. The majority of works were portraits. Also included was an intriguing work depicting a maid-servant giving food scraps to a family of beggars (fig.60). The dispensation of charity was a popular motif in British art during the latter decades of the eighteenth century, designed to reflect not so much the plight of the needy as the philanthropy of the propertied classes. When Gainsborough's picture (which has been cut down at some stage) was engraved in 1801 as 'Charity Sympathising with Distress', it was inscribed with a dedication to 'the Nobility & Gentry, whose humane exertions are employed in alleviating the distresses of the Poor'. Yet Gainsborough had given the picture an ironic twist, for the beggar woman, loaded down with children, her breasts partially exposed, is herself an allegorical figure of Charity, one of the three Christian Virtues. Her emblematic status is confirmed by the presence of a white dove fluttering above her head, surely a covert reference to the Holy Spirit. By giving alms the wealthy provide for the poor. Yet, through presenting an opportunity for benevolence, it is Charity herself who bestows the greater gift. This, perhaps, is the moral of Gainsborough's picture. One final point, which some contemporaries may have picked up on, is that Gainsborough's beggar woman is modelled upon a figure of Charity by Reynolds, one of a series of emblematic 'Virtues' then being installed in New College Chapel, Oxford.

Gainsborough's desire to extend the scope of his art emerges most forcibly in the series of fancy pictures that he began to paint during the 1780s. In 1783 he exhibited his most ambitious fancy picture to date, *Shepherd Boys with Dogs Fighting* (fig.61). This uncharacteristically violent image explores the perverse nature of cruelty, as one boy, his face set in a sadistic smile, intervenes to prevent the other from beating the dogs, thus curtailing what is for him an enjoyable spectacle. As Gainsborough was well aware, the picture's subject was perplexing. In a letter he teased the Academy's Treasurer, William

60 *Charity relieving Distress* 1784
Oil on canvas  Cut down to 98 × 76.2 (38½ × 30)
Private Collection

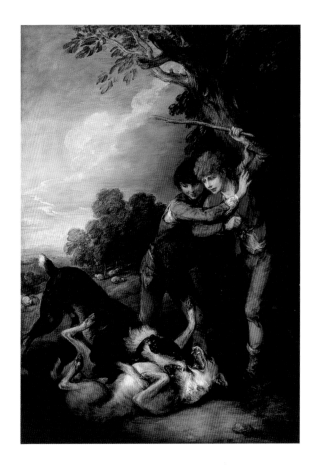

61 *Shepherd Boys
with Dogs Fighting*
1783
Oil on canvas
223.5 × 167.6
(88 × 66)
English Heritage
Kenwood House;
Iveagh Bequest,
London

Chambers, over its meaning: 'I sent my fighting dogs to divert you. I believe next exhibition I shall make the boys fighting & the dogs looking on – you know my cunning way of avoiding great subjects in painting & of concealing my ignorance by a flash in the pan.'[21] In fact, the picture demonstrates Gainsborough's keen attention to the traditions of Western art, and at least one critic at the time compared it favourably with Murillo and the Flemish animal painter Frans Snyders. While Gainsborough had been greatly influenced by both these artists, his specific choice of iconography, it has been suggested, was drawn from Titian's famous *St Peter Martyr* and from Hogarth, who had tackled the issue of animal cruelty in his print series, the *Stages of Cruelty*.[22]

In the spring of 1785 Gainsborough painted *Cottage Girl with Dog and Pitcher* (fig.62). According to Bate-Dudley, the child in the picture was a young peasant girl whom Gainsborough had met near Richmond Hill. Today this work can appear unsettling, as the attractiveness of the pre-pubescent child threatens to subvert the power of the image to convey the harsh realities of rural poverty. There is no indication that Gainsborough's contemporaries found the picture anything other than 'natural and pleasing'. This was borne out by the fact that it was snapped up almost immediately for the princely sum of 200 guineas, twice as much as Gainsborough was able to command for his full-length society portraits. The child in Gainsborough's *Cottage Girl* was an

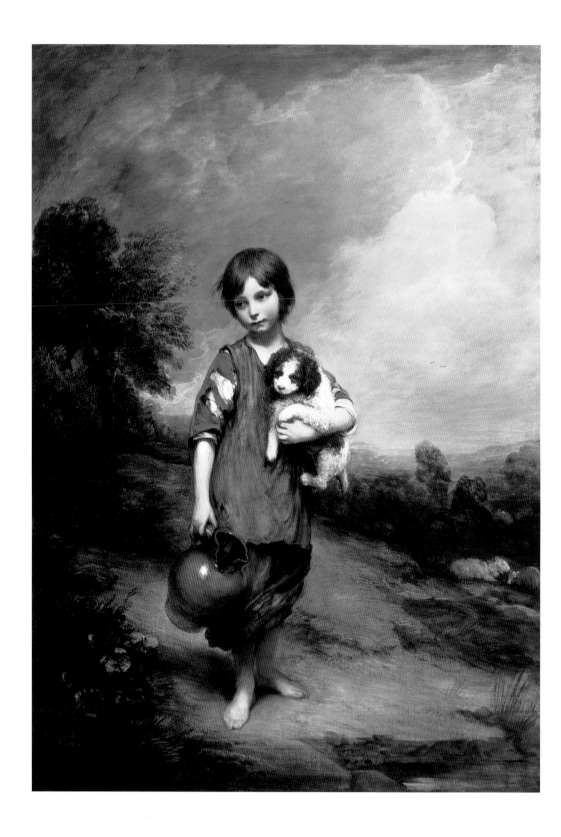

object of desire. This desire was legitimised by the fact that the young girl was a pictorial descendant of the beggar children of Murillo, whose art had inspired Gainsborough's own creation. The child in Gainsborough's picture ostensibly acted as a spur to perform charitable works, since the poor were then regarded optimistically as an enduring opportunity for philanthropy rather than a mere blot on the landscape. Here the potential of the child to elicit an emotive response is increased by the responsibilities she carries: the puppy cradled in her arm and the pitcher. These emblems elevate the child to iconic stature, as this secular image assumes the moral high ground of sacred art. The pitcher, in particular, has a connotation in Christian iconography relating to mortality. Its fragility is highlighted in Gainsborough's painting through its fractured surface, a reminder, perhaps, of the frailty of the child's innocence.

In the same year that Gainsborough painted *Cottage Girl* he was commissioned to paint the double portrait of Mr and Mrs William Hallett (fig.63), for which he was paid 120 guineas. Since the 1950s the picture has belonged to the National Gallery in London, where it hangs within a stone's throw of Gainsborough's *Mr and Mrs Andrews* (see fig.11). A comparison between the two pictures, separated by a gap of thirty-five years, is instructive. The subject matter in both works is identical: a young, newly married couple that has recently inherited landed estates, depicted in a landscape setting, attended by a dog. There the similarity ends. While Mr Andrews is teamed with his gun

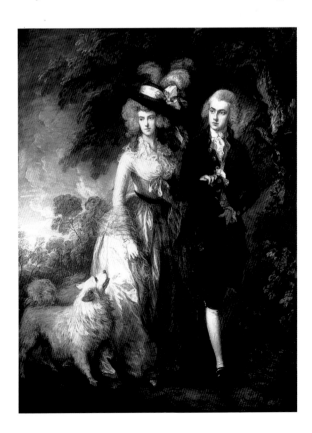

dog, Mr Hallett links arms with his wife. The couple look for all the world as if they are walking down the aisle, nodding to family and friends. The animal is a family pet rather than a working dog, and attends Mrs Hallett, forming a virtual appendage to her flowing white dress. While the Andrewses are crisply picked out against the surrounding landscape, the Halletts blend in tonally and colouristically with their woodland scenery to the point of camouflage. Finally, whereas the early portrait stresses ownership, the later one renders an atmosphere of mutual love and affection. In his will, Hallett recorded that he had been married 'most happily for 48 years, as it was impossible to do otherwise with such a woman': this, despite the fact that he had by then frittered away both their fortunes on gambling.[23]

Early in his career Gainsborough had made it clear that painting portraits was something he did for money. At the same time he was quite ready to shelve paid commissions if a more interesting sitter came along. In 1785 he had the opportunity to portray the celebrated actress Mrs Sarah Siddons (fig.64), then in great demand on the stage and in artists' painting rooms. Only the previous year Reynolds had exhibited her at the Royal Academy in the guise of the Tragic Muse (Huntington Art Gallery, San Marino, California) – which presumably made Gainsborough covet her presence in his studio even more. Like Reynolds's picture, Gainsborough's portrait of Mrs Siddons was painted as a speculation, without, it seems, a particular purchaser in mind. Now that his gallery was his sole exhibition space Gainsborough would have been especially keen to boost its prestige through the presence of celebrity. He duly exhibited the picture at Schomberg House, before lending or possibly giving it to Mrs Siddons. Although she was the most famous actress of her day, Gainsborough did not depict her in a stage role. This was a quite deliberate strategy, for, as Henry Bate-Dudley commented pointedly, her 'features are without that theatrical distortion which several painters have been fond of delineating'.[24] In Gainsborough's hands Mrs Siddons is remote and inscrutable, an ice queen whose apotheosis is suggested by the profile pose and the subject's fixed, distant gaze. Clothed in fashionable silks and fox furs, she is the epitome of high fashion, and quite beyond reach.

Gainsborough was gregarious and voluble, but when he painted portraits he at times appears to have detached himself from his sitter. It may be for this reason that his portraits seldom display the animation and characterisation achieved by Reynolds in his best works. Paradoxically, while Reynolds was able to respond to the personae of portrait sitters he lacked Gainsborough's creative imagination. Reynolds spent an entire career promoting the importance of history painting in the formation of a national school of art. It was left to Gainsborough, who professed complete indifference to the lofty traditions of High Art, to produce a painting which has a claim to be considered as the greatest historical painting produced by any British artist of the eighteenth century, *Diana and Actaeon* (fig.65). What prompted Gainsborough to turn to this subject from Ovid's *Metamorphoses* is uncertain. Recently, it has been presented as a parody upon Reynolds's academic theories, or, alternatively, as an attempt to fuse images of Christian baptism and pagan mythology.[25] Both arguments carry weight, in view of Gainsborough's spiritual leanings and his

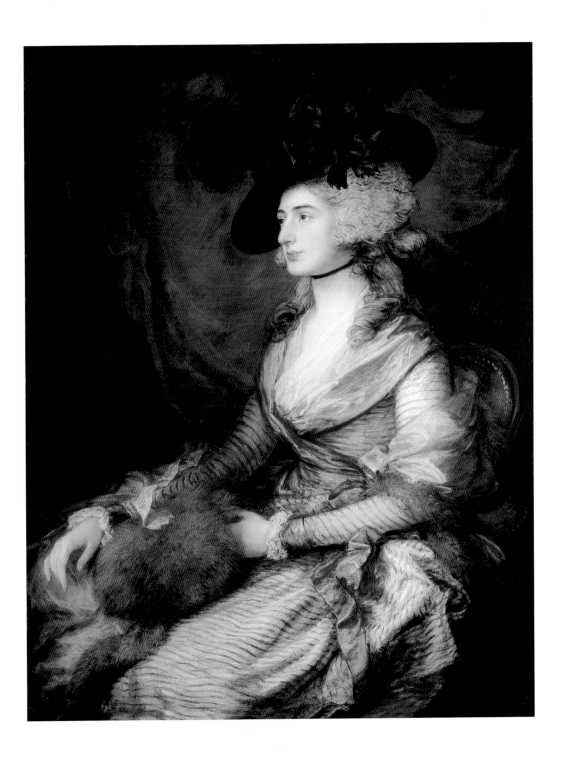

64 *Mrs Siddons* 1785
Oil on canvas 126 × 99.5 (49¾ × 39¼)
National Gallery, London

disdain for current academic norms. It is not, however, the artist's interpretation of his classical subject that commands the viewer's attention but the formal qualities of the painting: the manipulation of light and tone, the fluidity of its pigment and its compositional mastery. Viewed in these terms, comparison between *Diana and Actaeon*, Titian's nudes and Cézanne's heroic series of *Bathers* seems entirely justified.[26]

When, in the summer of 1788, Gainsborough was dying of cancer, he invited Reynolds to visit him. His rival did not reveal the details of what was said other than that 'his regret at losing life, was principally the regret of leaving his art'.[27] An erstwhile friend, William Jackson, published Gainsborough's alleged last words: 'We are all going to Heaven, and Vandyke is of the party.'[28] Given his reputation for eloquence, this parting shot has an undeniable romantic appeal. Jackson, however, was not at Gainsborough's deathbed, and another friend, who had been present, challenged his account. 'I was seated by His bed side when He died, and a little before He expired He uttered these words "Vandyke was right".'[29] This terse utterance, more than the 'Hollywood' ending scripted for him, confirms Van Dyck, not as Gainsborough's celestial companion, but as the role model he had adopted in his quest to succeed as artist, courtier and gentleman.

65 *Diana and Actaeon* c.1785
Oil on canvas
158.1 × 188
(62½ × 74)
The Royal Collection, Her Majesty Queen Elizabeth II

# Chronology

**1727** Thomas Gainsborough is baptised on 14 May at the Independent Meeting House in Friar's Street, Sudbury, Suffolk, the fifth son and ninth child of John Gainsborough and Mary Burrough.

**1739** Gainsborough's uncle, Thomas, bequeathes him £20 'that he may be brought up to some Light handy Craft trade'.

***c.*1740** Goes to London, where he is taught by the French designer, painter and illustrator, Hubert-François Gravelot.

**1743–4** Moves to rooms in a house in Little Kirby Street, Hatton Garden.

**1746** On 15 July, marries Margaret Burr at a private dwelling-house, which then served as St George's Chapel in Curzon Street. Moves with his wife to 67 Hatton Garden.

**1748** On 1 March, burial of Gainsborough's first child, Mary, at St Andrew's Church, Holborn.

**1748** On 29 October, death of Gainsborough's father.

**1749** Returns to Sudbury and lives in Friar's Street.

**1750** On 3 February, baptism of his eldest surviving daughter, Mary, at All Saints Church, Sudbury.

**1751** On 22 August, baptism of his younger daughter, Margaret, at St Gregory's Church, Sudbury.

**1752** In June, Gainsborough and his family move to Foundation Street, Ipswich.

**1758** In October, visits Bath, with a view to setting up his practice there.

**1759** Moves with his family to Bath.

**1760** On 24 June signs a seven-year lease on a house in Abbey Street, Bath, where he lives and runs his studio. Paints the portrait of Ann Ford.

**1761** Exhibits for the first time at the Society of Artists exhibition in London.

**1763** In the summer, contracts nervous fatigue, brought on by a venereal infection. Moves to a house in Lansdown, Bath, and lets off most of his town house except his painting room and 'the best parlour to show Pictures in'.

**1766** In December, moves his family and his painting practice to a house at 17 King's Circus, Bath.

**1768** Exhibits for the last time at the Society of Artists. In November, is invited by Sir Joshua Reynolds to become a member of the Royal Academy of Arts.

**1769** Exhibits at the first Royal Academy exhibition.

**1771** Exhibits *The Blue Boy* at the Royal Academy.

**1772** On 12 January, Gainsborough's nephew, Gainsborough Dupont (1754–97), is apprenticed to him.

**1773** Quarrels with the Royal Academy over the hanging of his pictures, and withdraws them from exhibition.

**1774** In the summer, moves with his family to a house at 80 Pall Mall, the west wing of Schomberg House.

**1777** Resumes exhibiting at the Royal Academy.

**1781** Exhibits portraits of George III and Queen Charlotte at the Royal Academy.

***c.*1782** Tours the West Country with Gainsborough Dupont.

**1783** Exhibits for the last time at the Royal Academy, including *Two Shepherd Boys with Dogs Fighting*. In the summer makes a tour of the Lake District. In the autumn visits Antwerp.

**1784** Quarrels with the Royal Academy over the hanging of his pictures and withdraws all his exhibits. In the summer, exhibits his paintings at Schomberg House.

**1788** On 2 August, dies in London. He is buried in Kew churchyard, near his friend, Joshua Kirby.

**1797** In January, death of Gainsborough Dupont.

**1798** On 18 December, death of Gainsborough's wife.

# Notes

## Chapter One: 'nature was his teacher'

1 Hayes 2001, p.168. The letter, which is dated 11 March 1788, was published in the *Morning Herald* in 1789. See Hayes 1982, II, pp.343–4.

2 *Morning Herald*, 4 Aug. 1788; *Morning Chronicle*, 8 Aug. 1788.

3 Sir Joshua Reynolds, *Discourses on Art*, ed. Robert Wark, New Haven and London 1975, pp.254 and 252.

4 Richard and Samuel Redgrave, *A Century of British Painters*, London 1866, repr. Oxford 1947, p.72.

5 See David Tyler, 'The Gainsborough Family: Births, Marriages, and Deaths Re-examined', *Gainsborough's House Review*, 1992/3, p.40.

6 See Adrienne Corri, 'Gainsborough's Early Career: New Documents and Two Portraits', *Burlington Magazine*, vol.125, April 1983, p.214.

7 *Morning Herald*, 4 Aug. 1788.

8 Letter, 11 March 1788. See n. 1 above.

9 André Rouquet, *The Present State of the Arts in England*, 1755, repr. London 1970, p.24.

10 *The Works of the Late Edward Dayes*, ed. E.W. Brayley, London 1805, p.329.

11 Grignion reported to Joseph Farington: 'Gravelot was a designer but could not engrave. He etched a great deal in what is called the manner of Painters etchings, but did not know how to handle the graver' (*The Diary of Joseph Farington*, ed. Kenneth Garlick, Angus Macintyre, Kathryn Cave, 17 vols., New Haven and London 1978–84, VIII, p.2800).

12 Ibid., VI, p.2435.

13 George Williams Fulcher, *Life of Thomas Gainsborough, R.A.*, London 1856, p.29.

14 For Hayman's relationship with Gainsborough see Brian Allen, *Francis Hayman*, New Haven and London 1987, pp.39–43.

15 Hayes 1982, I, p.33, fig.33.

16 Allen, *Francis Hayman*, cat.12, pp.92–3.

17 Rica Jones, 'Gainsborough's Materials and Methods. A "remarkable ability to make paint sparkle"', in Foister, Jones and Meslay 1997, p.24.

18 *Morning Chronicle*, 8 Aug. 1788.

19 See Hayes 1982, I, p.60.

20 *National Art Collections Fund Annual Report*, 1992, pp.122–3.

21 See David H. Solkin, *Painting for Money: The Visual Arts and the Public Sphere in Eighteenth-Century England*, New Haven and London 1993, pp.159–76.

22 Foister, Jones and Meslay 1997, p.20.

23 See Hugh Belsey, *Gainsborough's House Review*, 1991/2, pp.16–17, fig.2.

24 See Ellis Waterhouse, *Painting in Britain 1530–1790*, London 1953, p.184.

25 Rica Jones has suggested to me that the curious omission of the game bird may have been a private joke between artist and patron, directed at Andrews's poor shooting ability. But see also Egerton 1998, pp.84–86.

26 Hugh Prince, 'Art and Agrarian Change, 1710–1815', in Denis Cosgrove and Stephen Daniels, eds., *The Iconography of Landscape: Essays on the Symbolic Representation, Design and Use of Past Environments*, Cambridge 1988, p.103.

27 *Morning Chronicle*, 8 Aug. 1788. The quotation is borrowed from Alexander Pope's 'Epitaph on Sir Godfrey Kneller'.

## Chapter Two: 'the curs'd Face Business'

1 Hayes 2001, p.78.

2 Ibid., p.80.

3 I am grateful for this information to Rica Jones, who carried out a technical examination of the picture on behalf of Tate.

4 Asfour and Williamson 1999, pp.93–4.

5 Hayes 2001, p.5.

6 Ibid., p.6.

7 Rosenthal 1999, p.20.

8 Asfour and Williamson 1999, pp.89–91.

9 See Vaughan 2002, p.68, fig.54.

10 Hayes 2001, p.118.

11 Thomas Bauman, in John W. Yolton, ed., *The Blackwell Companion to the Enlightenment*, Oxford 1992, p.342.

12 Hayes 2001, p.10.

13 See Sumner 1988, p.10; Susan Legouix Sloman, 'Gainsborough in Bath in 1758–59', *Burlington Magazine*, vol.137, August 1995, pp.509–12; Michael Rosenthal, 'Testing the Water. Gainsborough in Bath in 1758', *Apollo*, vol.142, Sept. 1995, pp.49–54.

14 Susan Legouix Sloman, 'Gainsborough and "the lodging-house way"', *Gainsborough's House Review*, 1991/2, pp.23–43.

15 Fulcher 1856, p.102.

16 Hayes 2001, p.42.

17 Rosenthal 1999, p.167.

18 Ibid., pp.167–73.

19 Sir Joshua Reynolds, *Discourses on Art*, ed. Robert Wark, New Haven and London 1975, p.253.

20 Helen Glanville, in Waterfield 1988, pp.21–2.

21 Ozias Humphry, MS, Original Correspondence of Ozias Humphry, Royal Academy of Arts.

22 *Morning Chronicle*, 8 Aug. 1788.

23 Reynolds, *Discourses on Art*, p.72.

24 See Sloman, 'Gainsborough and the "lodging-house way"', pp.23–32.

25 See Hugh Belsey, *Love's Prospect. Gainsborough's Byam Family and the Eighteenth-Century Marriage Portrait*, exh. cat., Holburne Museum of Art, Bath 2001, pp.19–20.

26 Hayes 2001, p.90.

27 Rosenthal 1999, p.28.

28 Ibid., pp.25, 27.

29 Asfour and Williamson 1999, pp.98ff.

30 Reynolds, *Discourses on Art*, p.253.

31 Rosenthal 1999, p.46.

32 Ibid., p.47.

33 Hayes 1975, p.214.

### Chapter Three: 'Composition in the Landskip way'

1 The story of the picture's mutilation was told by Joshua Kirby's descendant, the Revd Kirby Trimmer. See Walter Thornbury, *The Life of J.M.W. Turner, R.A.*, London 1862, II, pp.59–60. See also Hayes 1982, II, p.375.

2 See Hayes 1982, I, p.183 and p.186 n.83.

3 They were *Mrs Siddons* and *Dr Ralph Schomberg*, both acquired in 1862.

4 Allan Cunningham, *The Lives of the most Eminent British Painters*, 1829, repr. London 1879, I, p.279.

5 Richard and Samuel Redgrave, *A Century of British Painters*, London 1866, repr. Oxford 1947, pp.67–8.

6 See Hayes 1982, II, pp.383–6.

7 See Barrell 1980, pp.6ff.

8 Ibid., pp.36–41.

9 Quoted in Whitley 1915, p.41.

10 Marcia Pointon, 'Gainsborough and the Landscape of Retirement', *Art History*, vol.2, no.4, Dec. 1979, pp.441–55.

11 Hayes 2001, p.68.

12 Ibid. and n.6.

13 Rosenthal 1999, p.47.

14 Whitley 1915, p.369.

15 Sir Joshua Reynolds, *Discourses on Art*, ed. Robert Wark, New Haven and London 1975, p.250.

16 Ozias Humphry, MS, Original Correspondence of Ozias Humphry, Royal Academy of Arts.

17 Reynolds, *Discourses on Art*, pp.250–1.

18 Rosenthal 1999, p.213.

19 Asfour and Williamson 1999, p.259.

20 John Hayes, 'Gainsborough and Rubens', *Apollo*, Aug. 1963, p.91.

21 Rosenthal 1999, p.202.

### Chapter Four: 'Thomas Gainsborough, R.A.'

1 *Morning Post*, 25 April 1777, p.4. Bate-Dudley wrote under the pseudonym 'Guido'.

2 Hayes 2001, pp.112–13.

3 Ibid., p.90.

4 See Robyn Asleson and Shelley M. Bennett, *British Paintings at the Huntington*, New Haven and London, 2001, pp.106–7.

5 Ibid., p.106.

6 Ibid., p.134.

7 Hayes 2001, p.83.

8 Rosenthal 1999, p.69.

9 Hayes 2001, p.83.

10 Ibid., p.115.

11 Susan Legouix Sloman, 'Gainsborough and "the lodging-house way"', *Gainsborough's House Review*, 1991/2, p.23.

12 See Asleson and Bennett, *British Paintings at the Huntington*, pp.92–100.

13 Hayes 2001, p.164.

14 It was a reversal of his full-length portrait of the Countess of Chesterfield, which belonged to Gainsborough's patron, the Earl of Radnor. See Deborah Cherry and Jennifer Harris, 'Eighteenth-Century Portraiture and the Seventeenth-Century Past: Gainsborough and Van Dyck', *Art History*, vol.5, no.3, Sept 1982, pp.287–306.

15 Sir Joshua Reynolds, *Discourses on Art*, ed. Robert Wark, New Haven and London 1975, p.109.

16 Elizabeth Einberg, *Gainsborough's Giovanna Baccelli*, London 1976, pp.12–13.

17 Egerton 1998, p.111.

18 Ibid., pp.111–12.

19 For the relative influence of Rubens, Claude Lorrain and Gaspard Dughet on Gainsborough's landscapes in the context of contemporary critical accounts, see David A. Brennerman, 'Thomas Gainsborough's "Wooded Landscape with Cattle by a Pool": Art Criticism and the Royal Academy', *Gainsborough's House Review* 1995/6, pp.37–46.

20 'Gaudenzio', *St James's Chronicle*, 3–6 May 1777. Quoted in Brennerman, 'Gainsborough's "Wooded Landscape"', p.39.

21 Whitley 1915, pp.131–2.

22 *Morning Post*, 25 April 1777, p.4.

23 Ibid., 27 April 1778, p.4.

24 Whitley 1915, pp.168–9.

25 Ibid., p.173.

26 'Ensis', *London Courant*, 3 May 1781.

27 Asfour and Williamson 1999, pp.267–8.

28 Whitley 1915, p.261.

29 Hayes 2001, p.147.

30 *The Letters of Sir Joshua Reynolds*, ed. John Ingamells and John Edgcumbe, New Haven and London 2000, p.162.

### Chapter Five: 'the Apollo of the Palace'

1 Asfour and Williamson 1999, p.141.

2 Lloyd 1994, p.50.

3 Diary entry for 6 Jan. 1799, in *The Diary of Joseph Farington*, ed. Kenneth Garlick, Angus Macintyre and Kathryn Cave, New Haven and London, 17 vols., 1978–84, IV, p.1130.

4 Quoted in Lloyd 1994, p.17.

5 The house, which has hitherto been unidentified, was probably the property leased by Gainsborough at no.2 The Terrace, Richmond, between 1786 and 1791. It was bequeathed by the artist to his wife. I am grateful to John Cloake for this information.

6 Hayes 2001, p.161.

7 Henry Angelo, *Reminiscences*, 2 vols., London 1828, I, pp.191–3.

8 Hayes 2001, p.150.

9 Hayes 1982, I, p.138; Jonathan Mayne, 'Thomas Gainsborough's Exhibition Box', *Victoria and Albert Museum Bulletin*, vol.I, no.3, July 1965, pp.17–24.

10 Amal Asfour and Paul Williamson, 'A Second Sentimental Journey: Gainsborough abroad', *Apollo*, Aug. 1997, pp.27–30.

11 Hayes 1975, p.221.

12 Hayes 2001, p.153.

13 Hayes 1982, I, pp.149–56.

14 Whitley 1915, p.170.

15 *Gentleman's Magazine*, Dec. 1773, p.614, quoted in Hayes 1982, II, p.450.

16 Barrell 1980, p.82.

17 *Morning Herald*, 5 Nov. 1783.

18 Hayes 1982, II, p.520.

19 William Hazlitt, *Conversations of James Northcote, Esq., R.A.*, London 1830, p.259.

20 Hayes 2001, p.112.

21 Ibid., p.152.

22 Rosenthal 1999, pp.108–10.

23 Egerton 1998, pp.122–3.

24 Whitley 1915, p.236.

25 Rosenthal 1999, pp.266–74; Asfour and Williamson 1999, pp.226–37.

26 Lloyd 1994, p.49.

27 Sir Joshua Reynolds, *Discourses on Art*, ed. Robert Wark, New Haven and London 1975, p.252.

28 Whitley 1915, p.306.

29 Diary entry for 15 Nov. 1810 in *The Diary of Joseph Farington*, X, p.3799. The testimony came from Gainsborough's friend William Pearce (c.1751–1842), Chief Clerk of the Admiralty and an amateur writer. For Pearce see also Whitley 1915, pp.392–4.

## Bibliography

Asfour, Amal and Williamson, Paul, *Gainsborough's Vision*, Liverpool 1999.

Barrell, John, *The Dark Side of the Landscape: The Rural Poor in English Painting 1730–1840*, Cambridge 1980.

Belsey, Hugh, *Gainsborough's Family*, exh. cat., Gainsborough's House, Sudbury 1988.

Belsey, Hugh, *Gainsborough the Printmaker*, Aldeburgh 1988.

Bermingham, Ann, *Landscape and Ideology: The English Rustic Tradition, 1740–1860*, Los Angeles and London 1986.

Bensusan-Butt, John, *Thomas Gainsborough in his Twenties*, Colchester 1993.

Clifford, Timothy, Griffiths, Antony and Royalton-Kisch, Martin, *Gainsborough and Reynolds in the British Museum*, exh. cat., British Museum, London 1978.

Coke, David, *The Painter's Eye*, exh. cat., Gainsborough's House, Sudbury 1977.

Cormack, Malcolm, *The Paintings of Thomas Gainsborough*, Cambridge 1991.

Corri, Adrienne, *The Search for Gainsborough*, London 1984.

Egerton, Judy, *National Gallery Catalogues: The British School*, London 1998.

Foister, Susan, Jones, Rica and Mesley, Olivier, *Young Gainsborough*, exh. cat., National Gallery, London 1997.

Fulcher, George Williams, *Life of Thomas Gainsborough*, London 1856.

Gockel, Bettina, *Kunst und Politik der Farbe: Gainsboroughs Portraitmalerei*, Berlin 1999.

Hayes, John, *The Drawings of Thomas Gainsborough*, London 1970.

Hayes, John, *Gainsborough as a Printmaker*, London 1971.

Hayes, John, *Gainsborough: Paintings and Drawings*, London 1975.

Hayes, John, *Thomas Gainsborough*, exh. cat., Tate Gallery, London 1980.

Hayes, John, *The Landscape Paintings of Thomas Gainsborough*, 2 vols., London 1982.

Hayes, John, *The Letters of Thomas Gainsborough*, New Haven and London 2001.

Hayes, John and Stainton, Lindsay, *Gainsborough Drawings*, exh. cat., Washington DC 1983.

Kalinsky, Nicola, *Gainsborough*, London 1995.

Lindsay, Jack, *Thomas Gainsborough: His Life and Art*, London 1981.

Lloyd, Christopher, *Gainsborough and Reynolds: Contrasts in Royal Patronage*, exh. cat., The Queen's Gallery, London 1994.

Rosenthal, Michael, *The Art of Thomas Gainsborough*, New Haven and London 1999.

Sloman, Susan, *Gainsborough in Bath*, New Haven and London 2002.

Spencer-Longhurst, Paul and Brooke, Janet M., *Thomas Gainsborough: The Harvest Wagon*, exh. cat., Birmingham Museum and Art Gallery and Art Gallery of Ontario, Birmingham and Toronto 1995.

Stainton, Lindsay, *Gainsborough and his Musical Friends*, exh. cat., Kenwood House, London 1977.

Sumner, Ann, *Gainsborough in Bath*, exh. cat., Holburne Museum, Bath 1988.

Thicknesse, Philip, *Sketch of the Life of Gainsborough*, London 1788.

Vaughan, William, *Gainsborough*, London 2002.

Waterfield, Giles, *A Nest of Nightingales. Thomas Gainsborough and the Linley Sisters*, exh. cat., Dulwich Picture Gallery, London 1988.

Waterhouse, Ellis, *Gainsborough*, London 1958.

Whitley, William T., *Thomas Gainsborough*, London 1915.

# Photographic Credits

# Index